Storm
OF THE Century

Storm

OF THE *Century*

THE REGINA TORNADO OF 1912

SANDRA BINGAMAN

University of Regina

CPRC PRESS

Printed and bound in Canada at Friesens.
The text of this book is printed on 100% post-consumer recycled paper
with earth-friendly vegetable-based inks.

COVER AND TEXT DESIGN: Duncan Campbell, CPRC.
EDITOR FOR THE PRESS: David McLennan CPRC.
MAPS: Diane Perrick and Duncan Campbell, CPRC.

Library and Archives Canada Cataloguing in Publication

Bingaman, Sandra, 1944–
Storm of the century : the Regina tornado
of 1912 / Sandra Bingaman.

(Trade books based in scholarship, 1482–9886 ; 31)
Includes bibliographical references.
ISBN 978–0–88977–248–9

1. Tornadoes—Saskatchewan—Regina. 2. Regina (Sask.)—
History. I. University of Regina. Canadian Plains Research
Center II. Title. III. Series: TBS ; 31

FC3546.4.B55 2011 971.24'4502 C2011-904873-6

10 9 8 7 6 5 4 3 2 1

Canadian Plains Research Center PressUniversity of Regina
Regina, Saskatchewan, Canada, s4s 0A2
TEL: (306) 585-4758 FAX: (306) 585 4699
E-MAIL: canadian.plains@uregina.ca
WEB: www.cprcpress.ca

We acknowledge the financial support of the Government of Canada
through the Canada Book Fund for our publishing activities.

Canadian Patrimoine
Heritage canadien

IMAGE AND PHOTOGRAPH CREDITS:

FRONT AND BACK COVER PHOTOGRAPHS: Saskatchewan Archives.

IMAGES AND PHOTOGRAPHS ON PAGES 3, 5, 6-7, 8, 10, 11, 12, 13, 14-15, 18, 19,
20-21, 22, 24-25, 28, 29, 30, 31, 32, 33, 34, 34-35, 36-37, 39, 42 (BOTTOM),
43 (TOP), 45, 46, 46-47, 52, 54, 55, 56-57, 58-59, 61, 62 (TOP), 62-63, 65
(TOP RIGHT, BOTTOM), 66, 66-69, 69, 75, 77, 79, 82, 84, 85, 87, 88-89,
90, 95, 96-97, 99 and 108 courtesy of Saskatchewan Archives.

IMAGES AND PHOTOGRAPHS ON PAGES 23, 40, 41, 42 (TOP), 43 (BOTTOM),
44, 48-49, 63 (TOP), 64, 65 (top left), 70-71, 73, 76, 80-81, 98, 100, 101, 103,
104 and 111 courtesy of the City of Regina Archives.

PHOTOGRAPH ON PAGES x-1 is a Saskatchewan Archives image
with a storm digitally superimposed.

PHOTOGRAPHS ON PAGES ix, 106-07 and 112
courtesy of David McLennan, CPRC.

PHOTOGRAPH OF MAYOR PAT FIACCO ON PAGE ix
courtesy of the City of Regina Mayor's Office.

PHOTOGRAPHS ON PAGE 114 (LEFT) *Dramatic Sky* by Dmitry Naumov
and (RIGHT) *Powerful Tornado* by James Thew, both from Veer.

Contents

To Jim with thanks for forty-five years together.

Foreword

There are moments in each of our lives that test our character and leave an indelible mark on who we are. It is the choices we make in the face of adversity that shape who we will become and where we are going.

The tornado that devastated Regina on June 30, 1912, is one of those moments in time. The Regina prior to June 30th was a progressive, vibrant, growing city attracting new residents from all over the globe. The signs of progress were everywhere from a newly constructed Legislative Building, known then as the Parliament Building, to the numerous kilometres of newly paved, tree-lined roads.

When the tornado struck on that hot June afternoon everything came to a standstill. With winds of anywhere from 333 to 418 kilometres per hour, the path of destruction was enormous. In its wake, nearly 30 people lost their lives and estimates put the damage at more than $1 million in 1912 funds.

In the days, months and years that followed, those individual early Reginans showed a characteristic prairie resolve to never give up. And as a city united, Regina demonstrated a powerful, committed civic pride—a feeling that lives on in the hearts and minds of its citizens to this day.

This book, *Storm of the Century: The Regina Tornado of 1912*, is a compelling look at the story of the people and events leading up to the storm, how that devastating event shaped the lives of thousands, and showed the enduring strength of prairie people. It is a must-have book for every resident, past, present and future to read.

Sincerely,

Pat Fiacco

Pat Fiacco,
Mayor of Regina

JAMES TEMPLETON *undid another button at the neck of his shirt and sat up on the edge of the bed. "Brother, it's hot!" he gasped. "Reminds me of that day last winter when I was in Houston, Texas. Intense, hot, sultry. Then, bammo! A cyclone whips out of the west and I find myself flat on my back."*

His roommate simply grunted, refusing to become involved in another long discussion of the Houston cyclone—he had heard the story twenty times already.

James Templeton moved to the window and looked out across the young city. From the room on the top floor of the Wascana Hotel he could see a few people on the street, but most were inside, or on front porches, trying to escape the heat. Otherwise, it was a typical Sunday afternoon in the prairie metropolis of Regina, Saskatchewan.

There was a difference. The morrow would be July 1—July 1, 1912—Dominion Day. Hundreds of flags and banners were flying, thousands of colored lights were strung across main thoroughfares, and seemingly miles of bunting festooned the quiet city. At that moment, the flags hung limply from their poles, the lights scarcely swayed, and the bunting looked wilted.

Suddenly, James Templeton became very attentive to a large black cloud that hung low over the southern skyline. "Hey, Bill! Come look at this!"

There was a compelling urgency in his voice that brought his companion to his side quickly.

To the southeast of the city, a dangerous looking cloud had formed and seemed to be moving rapidly towards the west. Even as they watched, they saw a similar cloud coming in from the southwest. Within the space of moments, the two ominous-looking clouds touched hands.

"It's a cyclone," Templeton whispered in awe. "It's just like some fabled giant!!"

As they watched, they saw a dark, sinister funnel stab earthward; they thought they could hear an awful roar—even though the clouds had joined at least ten miles south of them; then they thought they could detect a rapid movement of the storm towards the city. They waited no longer. With the cyclone-experienced James Templeton in the lead, they headed for the basement of their hotel.[1]

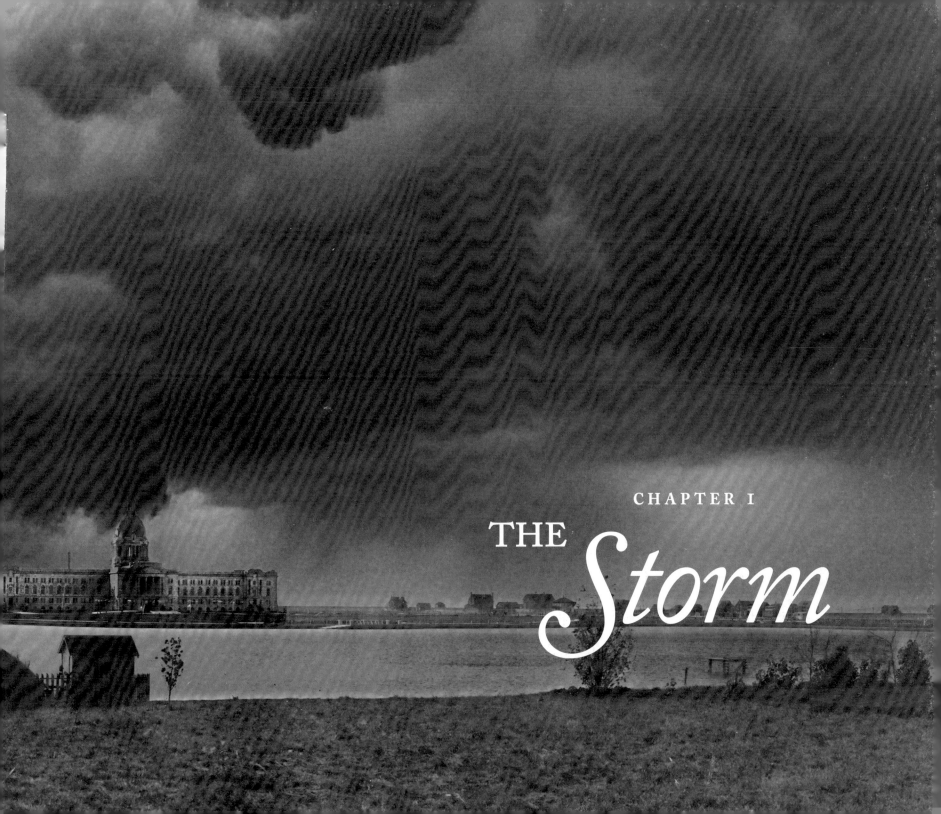

CHAPTER I
THE *Storm*

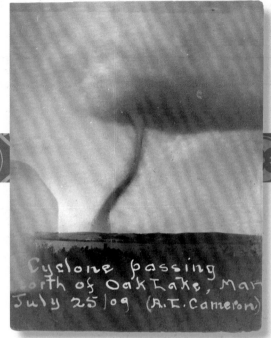

Cyclone passing north of Oak Lake, Man July 25/09 (A.I. Cameron)

There are no known pictures of the Regina storm, but this 1909 photograph shows a tornado which hit Manitoba.

The preceding prologue, based on an article which appeared in the Regina *Daily Province* newspaper in its first edition published after the storm, begins a popular history of the event described in the title *Regina's Terrible Tornado* written by Frank Anderson and published in 1968. It is an effective introduction because it describes both the conditions which spawned the storm, its awesome power, and the terror it struck in the people who saw it approach the city.

Many regions of North America are subject to violent windstorms such as the one which struck Regina on June 30, 1912. These storms arise when there is very moist warm air and atmospheric instability caused by an advancing cold front, which produces the dark clouds typically associated with thunderstorms. The collision of these air masses causes the warm air to rise quickly, and as it does so, more warm air rushes in to take its place. This rushing air starts rotating counter-clockwise, producing a narrow funnel cloud. If this whirling funnel touches the earth's surface, it can knock down structures and pick up objects in its path.

Storms like these which cover a wide area, as much as half a county, are called cyclones, while those smaller and more localized in area are called tornadoes.

The Regina *Leader*, another of the city's daily newspapers, attempted to explain the difference to its readers the day after the storm struck:

According to scientific descriptions, the storm which caused the holocaust in Regina was something of a cyclone and something of a tornado, its intimate description not tallying exactly with either, but somewhat with both.

A tornado is a local whirlwind of extreme violence, usually found within a thunderstorm. Its path on the earth is narrow, as it forms well above the clouds, and reaches down to earth in the shape of a funnel. It is a whirlwind, and at the same time travels forward with extreme speed, sometimes as high as 50 miles an hour. That, with its whirling motion, usually means destruction for whatever happens to be in its path.

A cyclone, on the other hand, is more scattered, to use lay language. It is an atmospheric system where the pressure is lowest at the centre, and the winds rotate spirally with a general rapid advance, like eddies in a swift stream.

Both these descriptions tally more or less with that of the storm which struck Regina yesterday. That of the tornado tallies more exactly, but the storm had some of the properties of a cyclone too.

The storm yesterday, according to observers who have seen cyclones and tornadoes in other countries and those who have scientific knowledge sufficient to record its progress with comparative accuracy, was marked by a core of extreme low pressure, with eddies in all directions.

For the past week, as barometric readings show, a condition of low atmospheric pressure has existed over the prairie provinces, and in this district particularly. The barometer told of the approach of the cyclone, but because such storms are unknown, or were until yesterday, in this country, it was taken to mean that a condition prevailed which in other countries would cause a cyclone.[1]

Notwithstanding the *Leader's* justification of its use of the word "cyclone" and its adoption by those involved in the storm, most historians have felt that "tornado" was the more accurate term.

The storm hit Regina in June, the second most common month for tornadoes on the Canadian prairies, at 4:50 in the afternoon, the most common time for them to occur because of daytime heating. It came from the south, the most typical direction, and had a very narrow base estimated to be from about 150 to 300 metres, the width of about three of Regina's city blocks.

Another characteristic of tornadoes is their terrifying sound, often compared to a fast-moving train. Part of this sound comes from the lightning and hail often associated with them.

"THE NOISE WAS LIKE FORTY THOUSAND SHRIEKING, HOWLING DEVILS LET LOOSE"

The swirling winds make a hissing sound as the funnel cloud extends towards the earth, a sound which then intensifies to a roar as it touches down. Added to this uproar is the sound of the destruction caused as buildings are either blown over or explode because the air pressure in them is higher than that of the low pressure area at the core of the storm. Most descriptions of Regina's storm include mentions of this deafening roar, such as this eyewitness account from the *Leader* on July 1:

The noise was like forty thousand shrieking, howling devils let loose; the rain fell in torrents, the lightning flashed with blinding brilliancy, it became so dark that I noticed through the windows that lights had been turned on in many houses. At the same moment there was a roar of thunder and the falling of bricks as both the chimneys of our house gave before the storm and fell with a crash on both sides of the house. At the same moment the telephone and light and power wires running through the lane at the rear of the house became broken and tangled and added to the horror of the scene by becoming short-circuited by the pools of water and creating a very alarming pyrotechnic display almost up against the garage door.[2]

Modern scientists have developed a rating system, called the Fujita Wind Damage Scale, for the damage done by tornadoes. This begins with rating F0 for storms with winds of from 40–70 miles per hour (64–113 kilometres per hour), which can damage tree branches, telephone lines and signboards. It contains categories of F1 through F5 with the last rating for a storm called "incredible" with wind speeds above 260 miles per hour (over 420 kilometres). On this system, the Regina storm rates as an F4 "devastating" tornado, with winds between 207–260 miles per hour (333–418 kilometres per hour) and enough power to destroy well constructed houses and turn large objects into flying missiles. Tornadoes of this magnitude are very rare in Canada, with Regina's storm rating among the highest ever recorded here.

Before this tornado struck Regina, however, it did damage to several farms south of the city, as the *Province* reported:

Reports which are coming in from the country show that the cyclone swept over a district

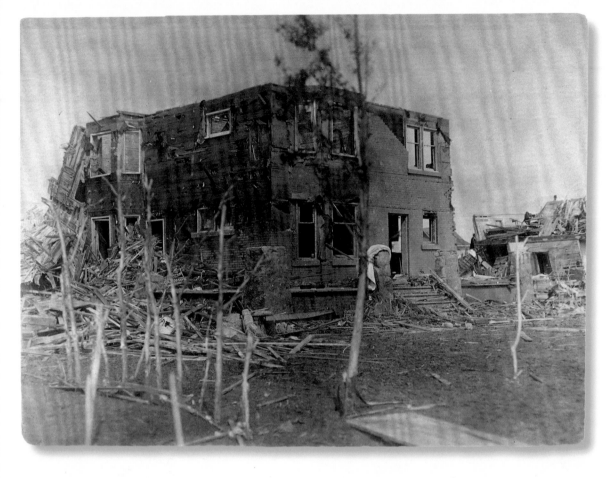

Tornadoes designated F4 have enough power to destroy substantial houses like this one in Regina's prosperous south end.

miles south of Regina was completely demolished and the contents of it and the barn are scattered for miles around. Mr. Dunlop has a wrenched ankle, while she is badly bruised, although not seriously.

Opposite their place was the residence of Mr. Robert Kerr. Mr. Andrew Roy of Howick, Que., was visiting at Mr. Kerr's and was instantly killed. Mrs. Kerr suffered serious injuries and Mr. Kerr is still in the Regina General Hospital. His little daughter had her arm broken. Nothing is left of the buildings, even the cement foundations being ground into powder.

Calvin Presbyterian church nearby is also badly wrecked. The next farm struck was that of John Mooney, which is rented by Mr. and Mrs. James, Old Country people. Both are in the hospital at Regina, along with their child and a hired man.

The cyclone destroyed the dairy farm along with the cattle of Thomas Elliott, and the stables of James Elliot, but missed both houses.

There are stories of damage as far north as eight miles, but no definite information has reached Regina, and it is hoped that the cyclone spent its fury on the prairies north, without doing any more damage.[3]

at least eleven miles southwest of here and many miles north. Farm houses which were in the track of its fury were picked up like paper boxes and smashed into kindling wood and traces of them are being found miles around. The furthest report of damage is at the home of Thomas Beare, about eleven miles southwest of Regina. His house and that of his son were swept away and all of the occupants were badly bruised and battered up, although not seriously.

The next house in the path of the storm was that of Walter Stephenson. He and his wife were badly injured and are still in bed. Mrs. Stephenson was picked up a hundred and fifty yards from the house. The force of the storm was such that she was practically stripped of her clothing. Incredible as it may seem even the shoes on her feet were torn off her. Mr. and Mrs. Stephenson come from Pickering country near Whitby, Ont. They were only married three months ago.

Another newly married couple who were victims of the cyclone were Mr. and Mrs. J. Dunlop, who came from western Ontario. They were married at Christmas. Their home which is only three

All of this damage, and the death of Andrew Roy, occurred before the tornado reached the city of Regina. However, the storm was moving so rapidly and communications were so slow that there was no way to warn citizens of the approaching danger. ❖

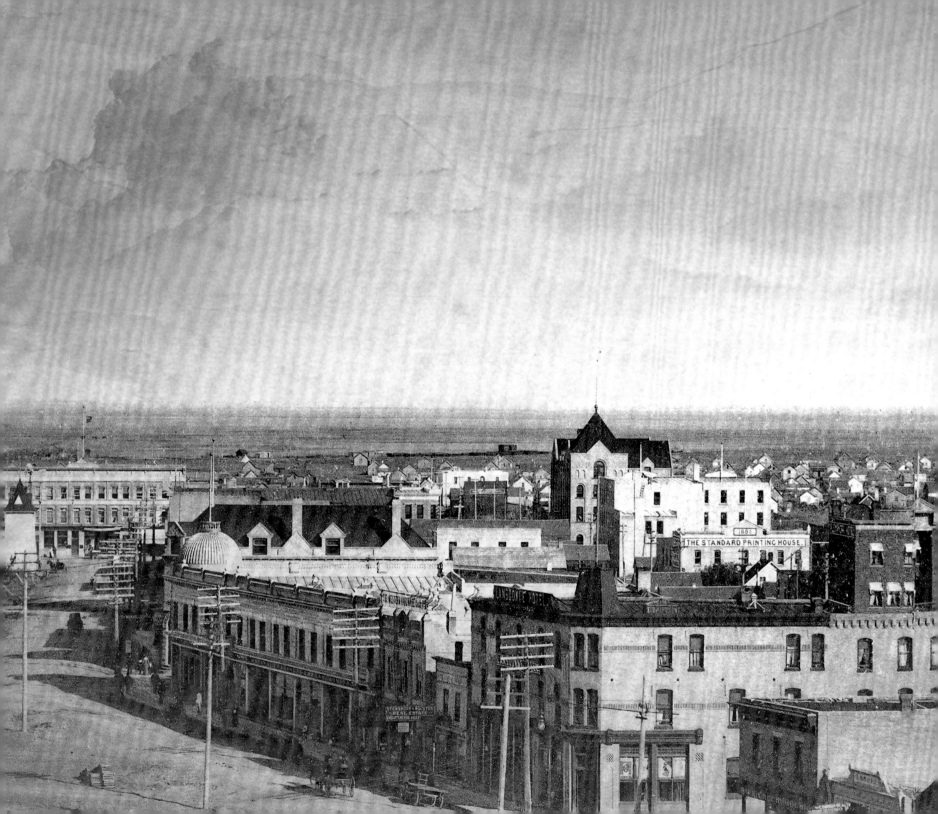

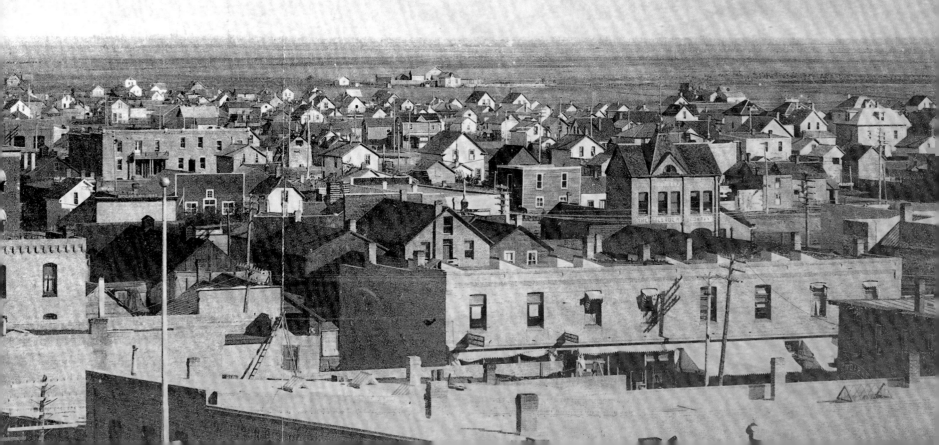

CHAPTER 2

THE *City*

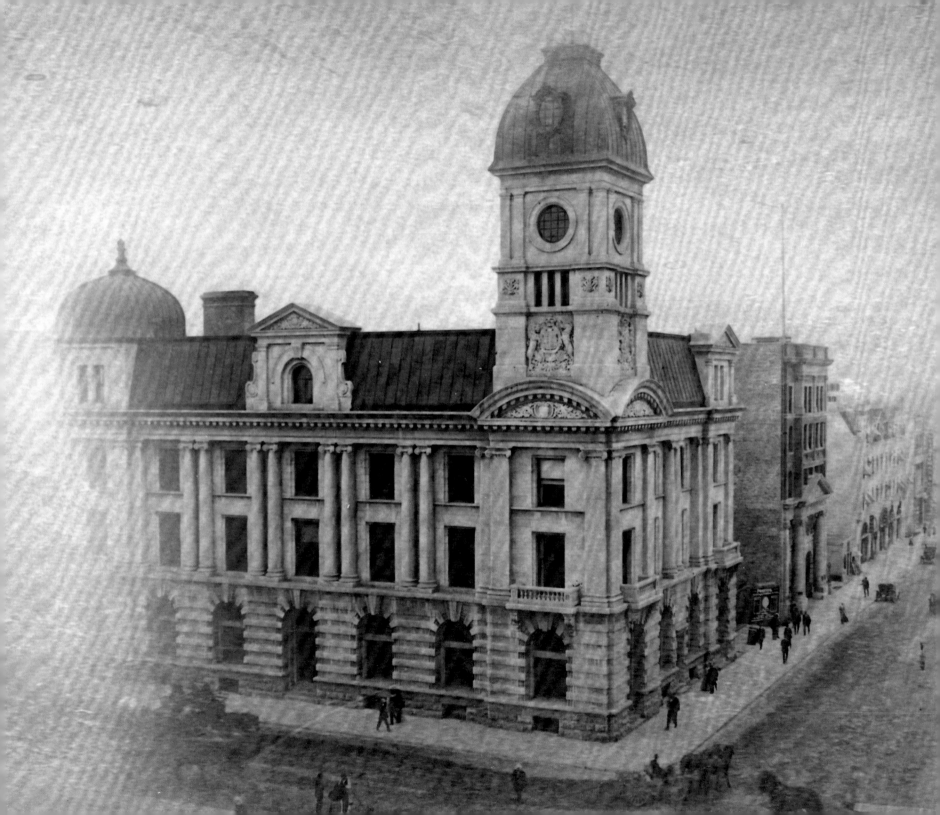

Very few cities in the Dominion of Canada can boast of having made such progress within the past few years as can the Queen City of the West—Regina, Saskatchewan.

Visitors to our city the past two months who have not been here within two years' time are astonished at the progress that has been made. Two years ago where the undulating prairie grasses waved in the breeze, now stand solid rows of business houses, residences and boulevarded streets.[1]

Thus boasted a 1911 pamphlet produced by Regina's business community to attract even more individuals and businesses to the community. The population of the city, which had been founded in 1882, had indeed grown very quickly since the turn of the 20th century, with census figures recorded as 2,249 in 1901; 6,169 in 1906, and 30,213 in 1911.[2] Another Board of Trade publication claimed that the number had risen to 40,000 in 1912, which it called a 1,400 percent increase in the last decade.[3]

FACING PAGE: Regina's second post office at the corner of 11th Avenue and Scarth Street was completed in 1907. It has served many purposes over the years. In 1909-10, the provincial government, having outgrown its Dewdney Avenue location, held its sessions here while construction of the new Parliament (Legislative) Building south of Wascana Lake was underway.

Other statistics used to illustrate the city's rapid growth were the total value of building permits and the number of firms involved in construction and real estate. Permits had totalled $5,099,340 for 1911 and were estimated at $8 million for 1912.[4] These covered all types of structures: office buildings, warehouses, churches, and apartment blocks. Three were for post-secondary school buildings along 16th Avenue: two worth $500,000 for the Methodist School which became known as Regina College, and one for the neighbouring Normal School for $300,000.[5] The construction of these buildings led to 16th Avenue being renamed

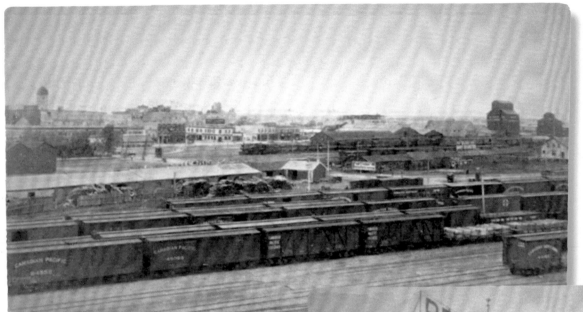

13 miles of paved roads and 42 miles of plank sidewalks, 26 miles each of water mains and sewers which connected to 2,700 houses, and an electric lighting system.[8] Telegraph and telephone service were available, and Regina could boast of three daily newspapers, the *Leader*, *Province*, and *Standard*. Children could receive their educations in one of five public schools, one Roman Catholic school, and a collegiate for the higher grades. Medical care was available at two hospitals, the Regina General which had room for 100 patients, and the recently opened Grey Nuns (now the Pasqua) with room for 84. The service which

College Avenue. With this amount of building activity, Regina could claim to be the second city in Canada in percentage growth. One claim in a promotional pamphlet went even further: "Regina is the largest point of distribution of agricultural implements in the world."[6] Two kinds of businesses which supported this growth were the 74 building contractors and the 157 real estate firms in the city in 1912; these compared to 17 and 37 respectively only four years earlier.[7]

The city could also claim to provide many amenities for its citizens. It boasted about its

THIS AND FACING PAGE: These photographs from a 1911 Board of Trade promotional pamphlet highlighted Regina's growth and prosperity.

which were lined with warehouses and small manufacturing plants. Just south of the tracks was the city's downtown core, the location of several banks, insurance companies, hotels, stores, and the numerous real estate firms. Also downtown were handsome new public buildings such as the city hall built in 1906 and the post office, both on 11th Avenue near several imposing bank buildings.

One of Regina's most photographed spots was Victoria Park, an area of two square blocks just south of downtown. The park itself had just recently been landscaped with a fountain, paths, and newly planted trees, since none grew there naturally. Around the western perimeter of the park were several recently constructed impressive public buildings. These included both the Young Men's and Young Women's Christian Associations (YMCA and YWCA), the land titles building, the public library, and three churches: First Baptist, Metropolitan Methodist, and Knox Presbyterian. Civic officials pointed to this area with pride because it showed that Regina could offer its citizens all the amenities of a larger city.

made many Reginans proudest was a newly opened street railway with six cars, one snow sweeper, and ten and a half miles of track. This system not only shaped the growth of the city with its tracks on 11th Avenue, Albert Street, 13th Avenue, and Dewdney Avenue, but also proved to the world that Regina was modern and metropolitan.

Promotional pamphlets about Regina highlighted certain sections of the city which showed it as prosperous and progressive. Two of these were of particular interest to businessmen. The city boasted large railway yards, particularly those of the Canadian Pacific Railway (CPR) running east and west through the centre of the city. Parallel to these were South Railway Avenue to the south and Dewdney Avenue to the north, both of

A possible rival to Victoria Park existed at the southern edge of the city. On the south shore of Wascana Lake, the provincial government had just completed construction of the Saskatchewan Legislative Building (known at the time as the Parliament Building) at a cost of $3 million. This impressive Tyndal stone structure housed the majority of the approximately 500 provincial civil servants. As part of the construction process, a new bridge and dam were built across Wascana Creek at Albert Street, and the lake behind the dam was deepened to make it more attractive.

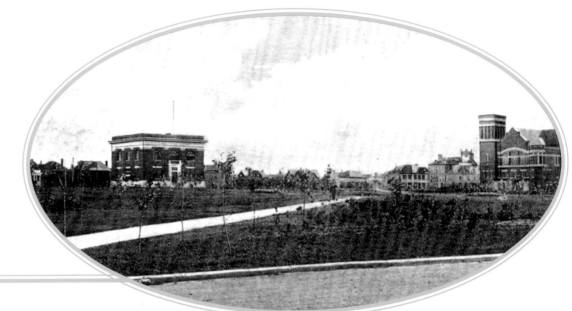

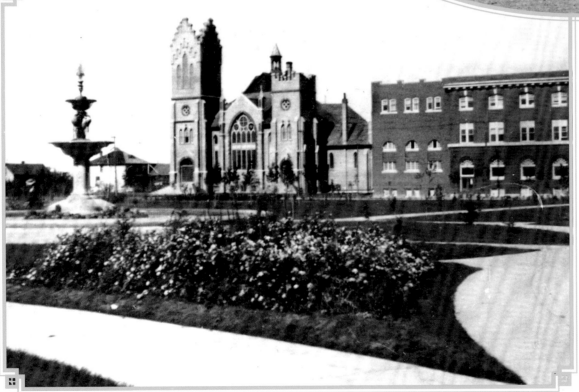

Also, provincial authorities began to landscape the area around the new building, even before its completion, to create a park. This construction activity also led to the start of a new subdivision, called Lakeview, just west of the Legislative Building, but by 1912 there were only a few dozen houses constructed there.

These two views of Victoria Park show its new landscaping:

ABOVE: This photograph, from a postcard, is looking southwest towards the Land Tjtles Building (left) and Metropolitan Methodist Church.

LEFT: This photograph looks north to 12th Avenue showing the YMCA (right) and Knox Presbyterian Church.

Regina's residential showplace, where successful Anglo-Saxon Protestant businessmen and professionals had their homes, was the area between the two parks. Bounded by Albert and Broad streets on the west and east respectively and by 16th (College) and Victoria avenues to the south and north, this area contained spacious homes with large landscaped yards. In this district, the streets were paved and almost all the houses had sewer and electrical service. A few even had garages for automobiles, which wealthy residents had begun to purchase. Pictures of these attractive homes often appeared in promotional pamphlets for the city.

Regina, however, also had areas which were not so photogenic. The majority of the city's citizens lived in districts to the west, east, and north of downtown, in much more modest homes with more limited services, but even these houses were in short supply given the incredible growth of the city's population. Many of these houses were little more than shacks, and most of them were overcrowded as people took in roomers to add to their incomes, with conditions made worse with no indoor plumbing or garbage removal. The people who lived in these situations were often new immigrants, many from Central or Eastern Europe, who spoke little or no English and thus had little hope of obtaining good jobs. The city's most visible minority were the Chinese, who usually ran or worked in laundries or restaurants located in all areas of the city. Wages for working-class people varied, with skilled tradesmen like bricklayers or plumbers

earning up to 70 cents per hour while ordinary labourers were paid about 20 cents, with long winter layoffs leaving them with no income for several months.[9] A few of the skilled tradesmen banded together to form unions and organize strikes, but they were not successful in making many gains from the conservative businessmen who controlled both Regina's commerce and civic government.

Even so, as they prepared to celebrate Dominion Day, July 1, 1912, by hanging flags and banners in parks and on public buildings, the civic leaders of Regina and many of its citizens were optimistic about the future. The signs of growth were everywhere, in new businesses and buildings, and in the ever-increasing population of the city. No one could foresee the storm clouds which very literally were gathering over the city ready to strike at its very heart. ❖

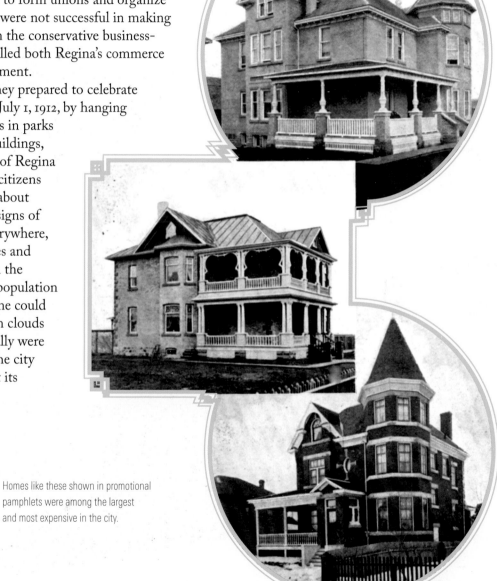

Homes like these shown in promotional pamphlets were among the largest and most expensive in the city.

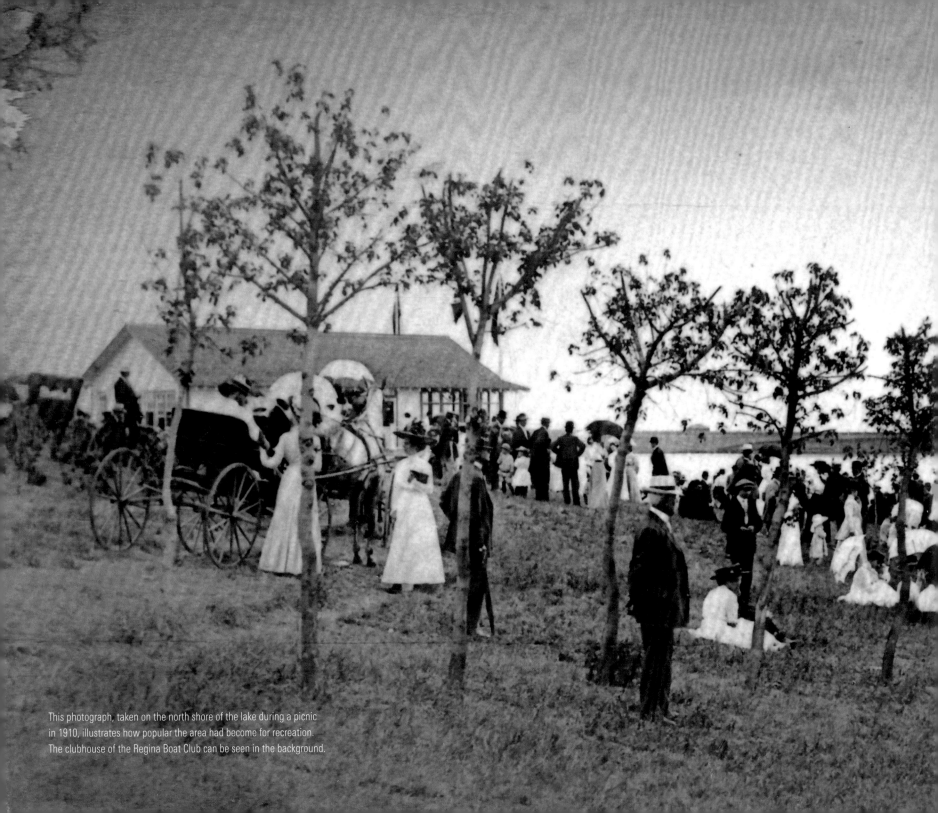

This photograph, taken on the north shore of the lake during a picnic in 1910, illustrates how popular the area had become for recreation. The clubhouse of the Regina Boat Club can be seen in the background.

Wascana Park

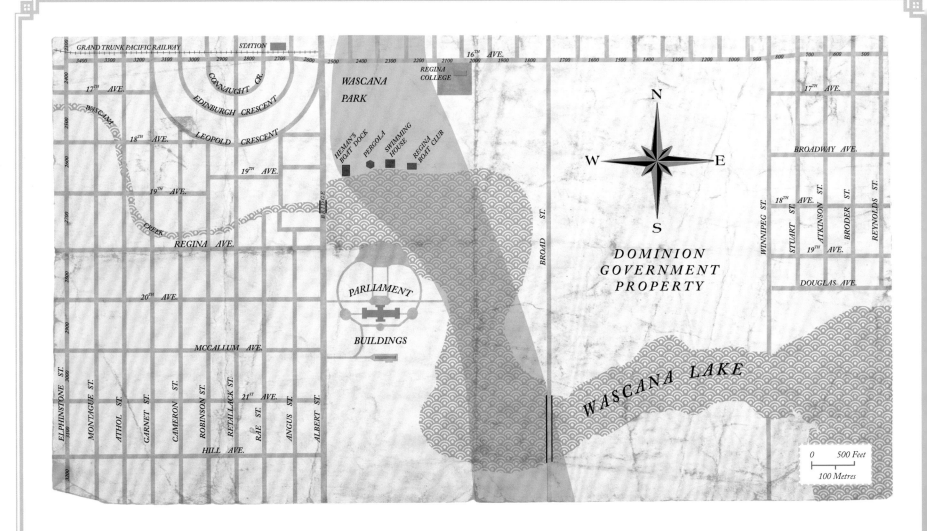

Wascana Park

■ —PATH OF THE TORNADO

FATALITIES:

Vincent H. Smith—North shore of lake, exact location unknown

Philip Steele —North shore of lake, exact location unknown

The first section of Regina struck by the tornado was the park on the south side of the city, surrounding Wascana Lake. There were no homes in this area, but the hot humid weather had led many people to the lakeshore seeking relief. These were the first of many to feel the storm's wrath.

The building dominating this area was the Legislative Building on the lake's south shore. This structure, started in 1908, had been recently completed although not officially opened (these celebrations took place on October 12, 1912). The building, then called the Parliament Building, housed the offices of the provincial government, but presumably it was empty of workers on a Sunday afternoon of a long weekend. The *Leader* reported the encounter between the structure and the storm:

Even the massive Parliament Buildings did not escape unscratched. The building itself stood the strain, but the windows on the south side were smashed in, with the result that many of the hollow tile portions were torn down and considerable damage done in many of the departments.

The damage was principally in the Museum, attached to the Department of Agriculture, the Government Printer's Office, the Law Library and Mr. Mahoney's office in the Attorney-General's Department, part of the Department of Railways and Telephones, and part of the Education Department.

The skylight in the Legislative Assembly chamber was broken and some damage done in the office of the clerk of the Assembly.[1]

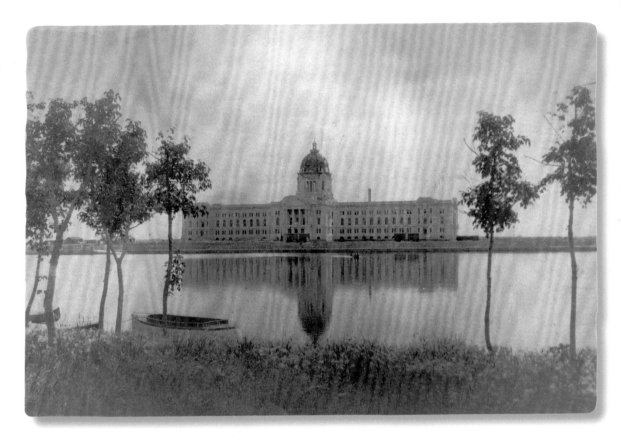

The legislative library and its contents were another area which suffered damage, as librarian John Hawkes reported. He had recently established this library in temporary quarters on the main floor on the south side of the building because its permanent location, across the hall, was not quite completed:

Then came the cyclone and smashed the whole business into a confused mass of plaster, broken glass, wood, books and papers, on the floors. This had to be retrieved, but the permanent rooms were also out of business, for the cyclone had broken out of the south rooms, crossed the corridor, and knocked two gigantic holes 20 or 30 feet long in the present library rooms.[2]

However, most of the books remained undamaged and, after being cleaned of debris, were moved to the room built for them.

Some of the documents in the building also suffered from wind and water damage. One of these was a manuscript of a two-volume history of Saskatchewan and the North-West Territories by Dr. Norman Black, which was soaked by rain and thus had to be rewritten.[3] Also destroyed were the recently written final examinations waiting for marking in the Department of Education: "Prankishly the wind flicked at a table in the Department of Education on which were piled the examination papers for all

Saskatchewan Grade Schools and flung them far and wide. As a result, teachers across the province had to pass, or fail, their pupils on their recollection of the year's work."[4]

In spite of this damage, provincial government officials were very pleased with the way the building withstood the storm's onslaught. The 1912 annual report of the Public Works Department stated, "The fact that the cyclone of 1912 left it, with the exception of windows and a few light partitions blown in on the south side, practically unharmed, is ample and sufficient evidence of its immobility."[5]

Regina's mayor Peter McAra recorded an odd bit of damage done in the vicinity of the Legislative Building. To help with the building's construction, a railway spur line had been constructed in front of the structure. According to the mayor, "The most freakish things happened in the cyclone and one was the complete disappearance of the cement from eight freight cars located on the tracks at the Parliament Buildings. This was found plastered on the ruins of the Metropolitan Church [on Lorne Street and Victoria Avenue, approximately one kilometre north]."[6]

The other structures in the park, those on the north side of the lake, did not escape the tornado so lightly. Also, they were full of people who had come to the area seeking relief from the heat and humidity which had blanketed Regina for more than a week. Many were swimming or boating on Wascana Lake, using the facilities of the boat club, swimming house, and a pergola on the north shore.

According to storm historian Frank Anderson, "Alex Rowbotham, who was guarding the valuables and clothing of his [swimming] friends at the pergola at Wascana, was probably the first person to realize the danger to the infant city as the giant twister came roaring around the majestic Legislative Buildings and ripped up the lake."[7] He told his story to a *Province* reporter who found him at his home the day after the storm:

All he remembers is seeing the roof go from over his head and then one of the walls falling in on him. When he regained consciousness there were at least half a dozen people lying around him and one man was on top of him. The man lying across him was uninjured and when he got up Rowbotham managed to drag himself across to what remained of the pergola. He was leaning up against one of the posts when a man warned him that it was not safe and then, seeing that he was badly injured, got another chap and they assisted him to Dr. Kells' office.[8]

Rowbotham was sure that his three friends had been drowned since he had not seen them, and was one of many suggesting that Wascana Lake was probably filled with bodies. However, a day later the *Province* reported that all three were safe, one completely unhurt and two with minor injuries. The same article also noted that other people swimming near the boat club had "managed to climb ashore in time and escaped without anything worse than bruises and minor cuts."[9]

In addition to swimmers, there were many boating on the lake when the tornado struck. Some had rented boats from Hemans's boat dock near the Albert Street bridge, while others were members of the Regina Boat Club further east.

According to the *Leader*, the group gathered at the boat club at first treated the approaching storm "with supreme contempt"[10]:

They saw it sort of come around the legislative buildings. Then it grew black overhead and someone said: "This is a big storm; let's get the boats in."
Mr. Wilkinson the secretary was there. He had sized it up as really serious and took command of the fellows. "Clear out of this verandah.

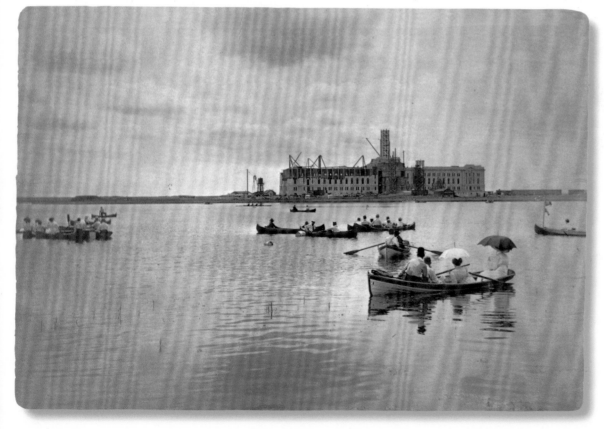

This photograph, taken while the Legislative Building was still under construction, shows how many people enjoyed canoeing and boating on the lake.

Get back in," he said. They had had hardly time to follow his instructions when the storm was on. Boats were driven in a heap to the bank and up on the land. They're not boats now.

Curiously enough, too, dinghies or cat boats were later found away down Smith Street. One little red canoe parted company with its rear section. Part of the hull is in Victoria Park.

The Boat Club buoys were pitched in a heap to the rear or north end of the building. The roof was lifted off but the whole building did not collapse. The piano remained in position.[11]

Although at the end of this article, the *Leader* reported that "none of the men were hurt more than cuts and bruises, minor wounds all," this was not the case. In the next column under the heading "Pranks of the Storm," the *Leader* stated that "Mr. Ray Coan, the well-known organist, was badly cut and bruised.

When the building gave way, several of the club members were dressing, one gentleman having nothing on save a shirt. The whole party were blown across the park, suffering considerably from contact with the bushes on route."[12]

Friends E. O. Gimson and Vincent Smith, formerly the mayor of Balgonie, were two other victims when the storm hit Wascana Park. From his bed where he was recovering from badly swollen feet, Gimson told a *Province* reporter that his friend, who had been found dead in the park at three o'clock Monday morning, had had a premonition of disaster and had thus been reluctant to go boating:

Vincent appeared to be downcast and nervous about something all day. I remarked this all through the day but when I would ask him what he feared, he would say, "Oh, nothing," and nothing more would be said for some time. We

finally decided to go ashore, and we went to the boat house fully fifteen minutes before the storm broke. The first gust of wind blew open the door, and we both jumped together to close it, but the second and more violent gust carried the door off, hinges and all, and that is the last I saw of Vincent. The next I remember was waking up in the park, so I must have blown up over the bank.

We searched for Vincent nearly all night, and I must have walked miles during that time. I did not notice any pain anywhere at that time, but look at those feet.[13]

The boat club itself in which these catastrophes had occurred suffered approximately $5,500 damage, although some of the building's contents did survive. The lockers at the clubhouse were still standing in the ruins so members were urged to retrieve their belongings from them. The secretary had saved the club's

financial records and reported that the club had a bank balance of $800 which they could use to begin rebuilding.[14]

Further west along the shore, Hemans's boat house was also in ruins, but owner C. W. Hemans, who had been in the building during the storm, told a reporter that he was "glad to have escaped alive." He stated that he was able to account for all his boats, but had found them "scattered all over Wascana Park."[15] One canoe ended up even further afield, as the *Leader* reported:

Mr. Soskin was barricaded behind a door in the Film Exchange on the fourth floor of the Kerr Block when a large section of a canoe crashed through the window and smashed to atoms against the opposite wall.[16]

This office building was located at 1864 Scarth Street, more than six blocks from Wascana Lake.

There were boys as well as men at Wascana Park the day of the tornado, and the details of their experiences have caused some confusion over the years. One was 13-year-old Leonard Marshall who told a reporter from the *Province*,

I was canoeing on Lake Wascana when I saw the storm coming. I paddled for shore, as fast as I could, but long before I reached land the clouds swooped down on me and the last thing I remember was the sensation of being hurled through the air. When I came to my senses someone was bending over me in the park.[17]

The calm before the storm: the Regina Boat Club's building is to the left, the newly completed Legislative Building is across the lake in the centre of the photograph, and the beginnings of the new residential area of Lakeview appear on the right.

21

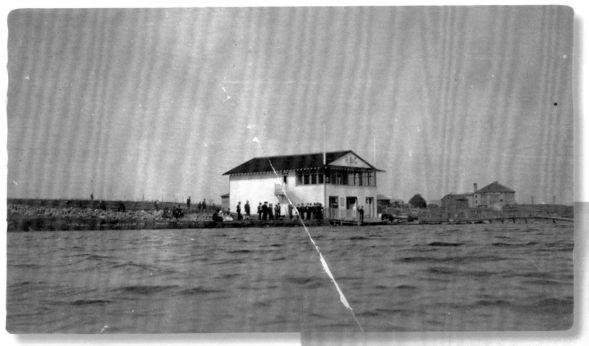

The clubhouse of the Regina Boat Club, a substantial building on the north shore of Wascana Lake (LEFT), was reduced to a pile of rubble by the storm (BELOW) and did not offer enough protection to save Vincent Smith from death.

FACING PAGE: Damaged canoes like this littered Wascana Park after the tornado.

AFTER CYCLONE 1912
FIRST REGINA BOAT CLUB HOUSE.

Marshall was obviously confused by his experience because he changed his story when he talked to a *Leader* reporter the next day:

I was in the boat house getting dressed, as I had been in swimming. Seeing the approaching storm, I got out of the water and took shelter. I had about half my clothes on when the storm struck the lake and the boat house with a terrible roar and crash of tearing timbers. What happened after the boat house was struck I can't say. I found myself about one hundred and fifty yards from the lake shore.

I don't know how I got there but the rain and hail revived me, and I got up after several trials and ran. The wind was still strong and carried me before it. I reached 16th Avenue and fell again. A Mr. Corbett came running past and I called to him and he took my hand and helped me to Wheatley's house on 16th Avenue.[18]

Leonard's mother was able to confirm that her son had arrived home muddy and bruised.

On July 3, the *Leader* briefly mentioned the fate of another young boy, 11-year-old Bruce Langton, whom, it claimed "rode his canoe far up into the park"[19] along with a friend who did not survive the ride. The experience had left Langton so shaken that "what happened next, he cannot very well remember. Indeed, it is something of an effort for him to recall his own first name. He was still too dazed to recall

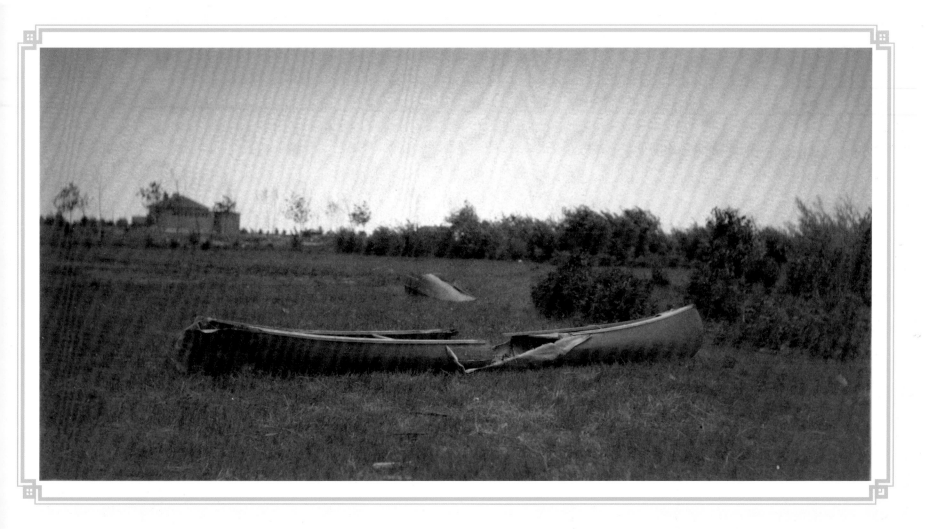

the name of his chum, who was killed, Philip Arthur Steele."[20] Years later a reporter contacted Philip Steele's brother, who claimed that he had been swimming, not canoeing, with his brother and Langton and had found his brother dead on the bank of Wascana Lake with no sign of Langton or any boat.[21]

By far the most serious loss in Wascana Park was the death of two people, Vincent Smith and young Philip Steele. The wooden buildings on the lake's north shore were destroyed and the boats associated with them were scattered far and wide. However, the majestic Legislative Building still stood, and the property damage was insignificant compared with what happened as the storm struck the more heavily populated parts of Regina.

One final measure of the storm's power in the park was noted by eyewitness Montagu Clements: "On the morning of the fateful day a government engineer had happened to notice that water was flowing over the Albert Street dam. After the tornado had gone by he again took the measure and estimated that two feet of water, representing millions of gallons, had been sucked out of the lake."[22] Most of this water was dumped on Regina's streets and combined with the torrential rains of the tornado to turn them into quagmires. ❖

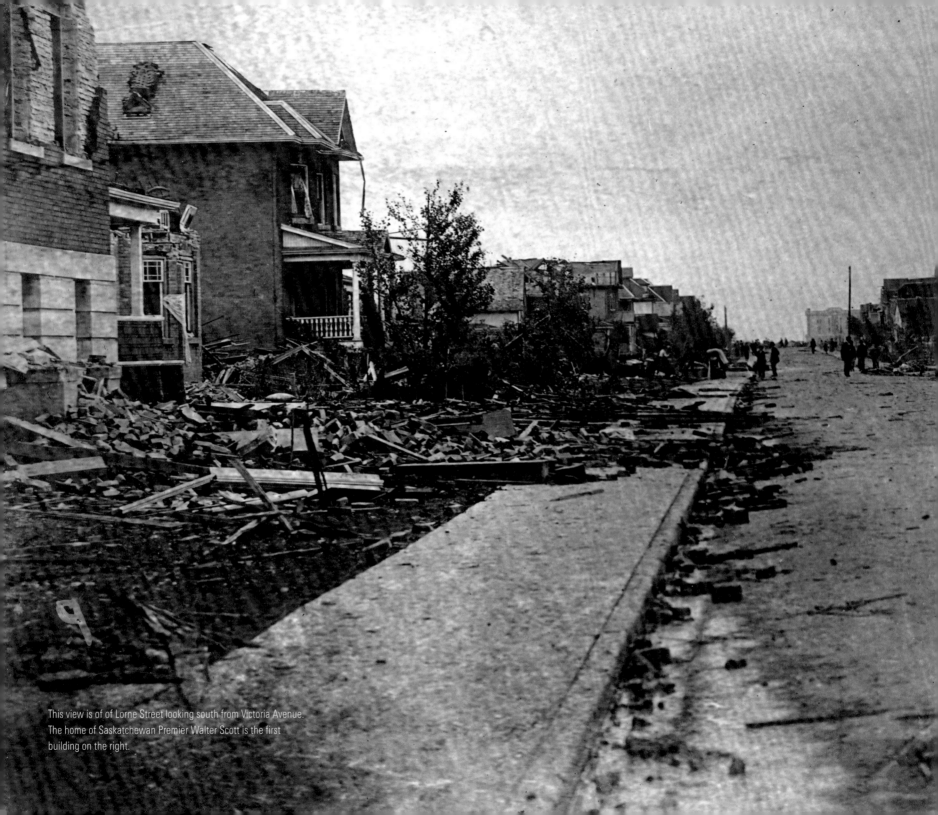

This view is of Lorne Street looking south from Victoria Avenue. The home of Saskatchewan Premier Walter Scott is the first building on the right.

CHAPTER 4

"THE *Best Residential District*"

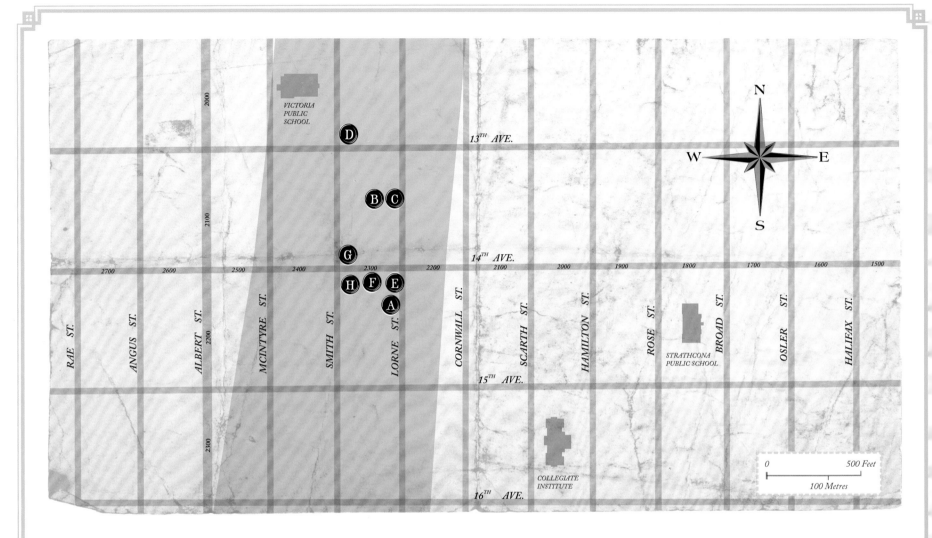

"The Best Residential District"

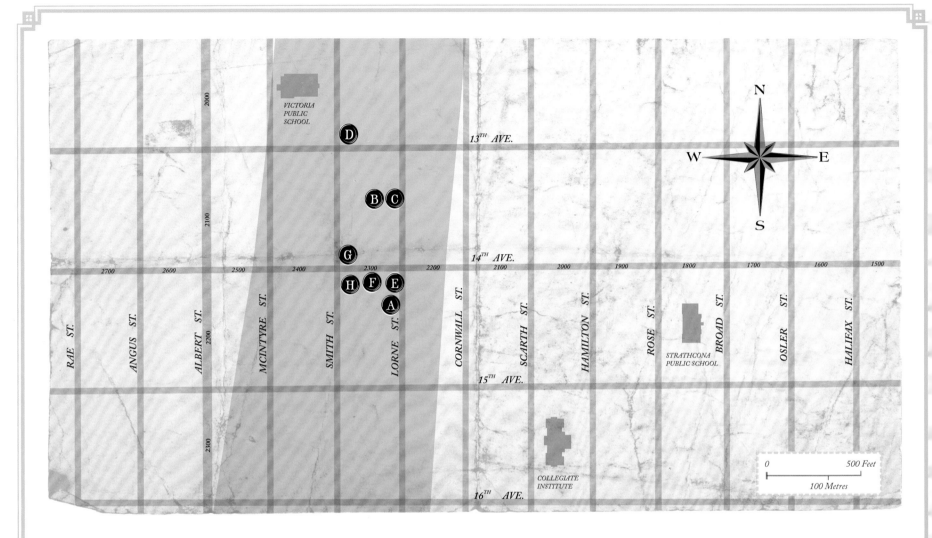—PATH OF THE TORNADO

FATALITIES:

Ⓐ *Fred Hindson*—2220 Lorne Street

Ⓑ *Etta Guthrie*—2138 Lorne Street

Ⓒ *Mrs. R. W. F. Harris*—2138 Lorne Street

Ⓓ *Ywe Boyuen*—Corner of Smith Street & 13th Avenue

Ⓔ *James Patrick Coffee*—2202 Lorne Street

Ⓕ *Andrew Boyd*—2202 Lorne Street

Ⓖ *Mrs. P. McElmoyle*—2318 14th Avenue

Ⓗ *Donald Loggie*—2201 Smith Street

After touching down near the Legislative Building and crossing Wascana Lake, the tornado headed straight north towards the houses in what was then Regina's south end. The district bordered by Albert Street on the west, Broad on the east, 16th Avenue on the south, and Victoria Avenue on the north was home to many of the city's most prominent citizens. These included Saskatchewan Premier Walter Scott and the area's member of Parliament, William Melville Martin, as well as successful professional and business leaders. The substantial and attractive houses in this area were often featured in pamphlets used to advertise the city to potential immigrants.

The destructive wind struck at the western edge of this district, with the storm's centre travelling along Smith and Lorne streets. Most of the homes in its path suffered extensive damage, although occasionally one would be spared while all those around it collapsed. Some of these houses were blown over by the storm while others almost literally exploded because the pressure in them was greater than the low pressure area of the storm. This pressure differential caused roofs to lift from buildings and walls to collapse outward. Photographs taken at the time clearly illustrate how much damage was done, as does a four-page list of losses in the *Standard*, the highest for homes being for M. McCausland at $30,000 and Judge Lamont at $25,000 (at a time when ordinary houses could be purchased for less than $5,000).[1] Although this article gave

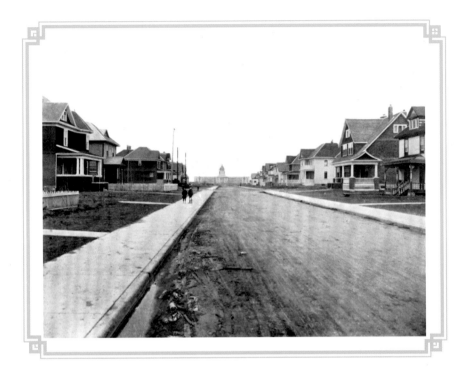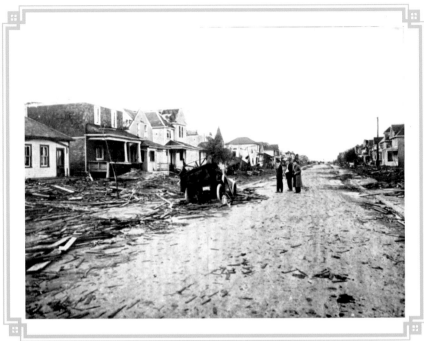

These contrasting photographs are from a contemporary pamphlet entitled *Regina Before & After Cyclone*. Both images were taken from approximately the same spot on Smith Street looking south: the one on the left before the tornado, the one on the right afterwards. Homes in this area were among the finest in the city, costing from $7,000 to $18,000 each.

individual damages for many residences and business, it also called the "whole east side of Smith street to Thirteenth ave. from Fourteenth a complete wreck," and estimated this block's "total loss at least $50,000."[2]

In the days following the tornado, the newspapers of Regina were filled with stories of people's experiences during the storm, some quite bizarre and others tragic. Judge J. H. Lamont was one of the prominent citizens who described the onset of the storm:

I watched the cyclone blow up from the south, but didn't realize how bad it was. I rushed upstairs to close the windows and was in the bathroom when the storm hit the house. I saw the wall giving way and rushed to the other side. Bricks, furniture, plaster and timbers rained around me. How I came out alive I cannot imagine. Mrs. Lamont was downstairs and was also uninjured. The walls of our house are still standing, but I guess it will have to be all torn down and started over again.[3]

At 2065 Lorne Street, across the street from the Lamonts, the house of Harry Potts was more completely destroyed, with only his piano stool left intact, although he escaped unharmed. He did, however, acquire a new possession, as he told a reporter who found him sitting on the stool in the midst of the ruins reading a book: "here is a strange coincidence. I found this book blown into my yard, and it is entitled: 'Business Hints for Beginners.' It must be Providence, for this loss means I will have to start to build a new house."[4]

At 2354 Smith Street, Mr. and Mrs. Beelby and their toddler had what the *Province* called "a miraculous escape. They were in the upper portion of their house when the cyclone struck them. The house was cut in two as if with a giant knife. The upper portion with the family was hurled through the air fully one hundred feet and landed on the other side of the road."[5] The *Leader*, which also carried this family's story, told of their frantic search for their older children after their home was destroyed:

Mr. Beelby then jumped through the broken window to search for his other children. He found the oldest girl and boy and a nephew on a verandah three doors away with debris of all kinds piled around them but [3-year-old] Florence was not in sight. After the rain subsided a little he found the child in the oven of the stove in the street. Her face is badly bruised and her ankle is black and blue. How she got there is a mystery.[6]

The Weeks family of 2216 Lorne Street considered themselves equally lucky even though both Mr. and Mrs. Weeks were injured as their house collapsed in ruins around them. The *Province* reported their experiences:

Fear of the lightning had driven the children to seek their mother and the family were together in the drawing room when the house commenced to rock. Mrs. Weeks threw the three eldest children under the grand piano and clutched the youngest to her breast. Both the parents were pinned to earth by the wreckage, and when they were released Mr. Weeks said to his wife, the child is dead: the kiddie was still tucked under the mother's arm, and called out, "No, I am not dead." The other three children were saved from the falling timbers by the grand piano, which was practically covered with the remnants of the house.[7]

Animals as well as humans were the victims of the storm's wrath. The July 2 edition of the *Leader* described some of their experiences:

Just behind a house on Albert street (between 14th and 15th avenues) when the tornado struck the city on Sunday afternoon a barn was lifted clear from the ground and hurled a hundred feet. A cow, who was the sole inmate, looked at her fast disappearing home and then apparently realizing the seriousness of everything, turned and disappeared on the horizon. An hour after she returned calling for her calf which, in the meantime had taken refuge behind a couple of demolished houses.

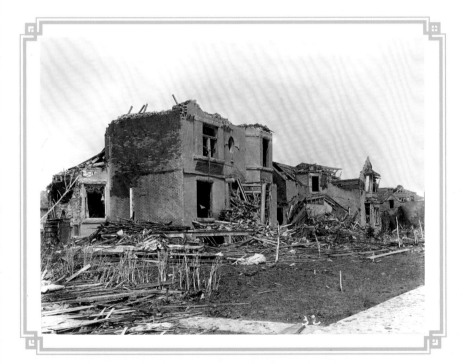

Judge J. H. Lamont and his family lived in this substantial house at 2060 Lorne Street. In spite of the extensive damage, no one in the home during the storm was seriously injured.

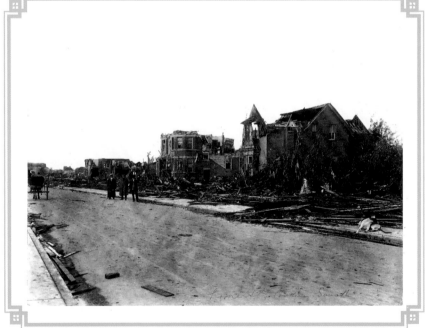

This photograph, taken from the opposite direction as the one at left, shows the ruins of the substantial McCausland residence in the foreground; that of the Lamont family is to the left of it.

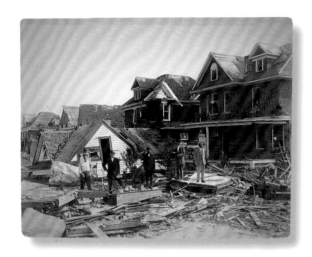

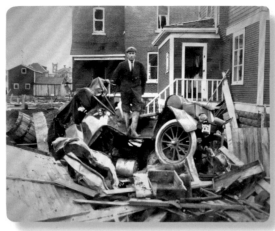

FAR LEFT: The top storey of the Beelby house, which was on Smith Street near 16th (now College) Avenue, was blown across the street, landing in a neighbour's front yard. Miraculously, the family members inside escaped serious injury.

LEFT: Cars as well as other kinds of property fell victim to the tornado, as this picture of Jack McKay shows. McKay was one of many who took photographs of the damage.

At the same house a number of chickens were blown a great distance from the house and after the storm were found uninjured.[8]

Family pets as well as livestock were affected:

At a home on Cornwall Street a dicky bird was left in its cage on the verandah, while the family to get a little relief from the intense heat went for a spin in their car. They returned just as the rain was beginning to fall, and in the excitement of seeking refuge for themselves forgot the bird. Just as the storm was well under way, the kindhearted mistress of the household remembered the bird and went out to rescue it. She found that the tail had been blown off and she was just bewailing the fact when suddenly furniture of all descriptions came crashing through the windows, *bringing wreck in its traces. When the worst was over—and only then—did she realize her great reason for thankfulness over the safety of her family, even if the bird must go without a tail.*[9]

Some of the residents of this area owned automobiles, many of which suffered storm damage. Auto salesman W. C. Swanson estimated that at least 35 cars were wrecked including "a new electric Galt car, complete in every respect, which he sold A. G. Weeks five weeks ago, and today it stands a total wreck on Fourteenth avenue, where the wind had blown it."[10]

RIGHT: This is one of many photographs of damage made into a post card. The unsigned note on the back read, *"This is Lorne St., or rather what was Lorne St. The two dogs were fast friends of ours. They are looking for their house which does not now exist."*

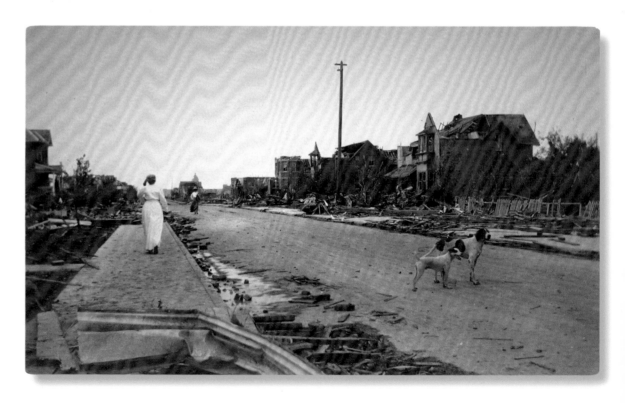

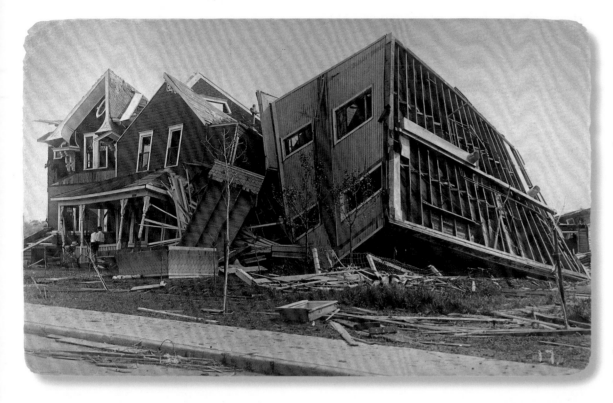

These three large homes in the 2200 block of Smith Street suffered irreparable damage.

Fred was probably hit with something and killed outright. He was thrown to the floor, and I was thrown in such a position that my hand was stretched over his body. He was lying still, and I instantly felt if he was dead. Douglas was near me, but managed to wriggle loose, and he directed the rescue party how to relieve me. I was pinned down by some timbers lying across my chest and bearing on my shoulder. I could scarcely draw a breath and could not have stood the heavy pressure on my chest very long. It is indeed a sad blow to lose poor Fred.[13]

Jack Anderson's car also appeared destroyed on top of a pile of debris with the rear end of the car wrenched off, but its owner won a bet of one dollar by claiming that he would be able to move it, which he did by simply cranking it to start the motor and then driving it away.[11] Howell Smith of Cornwall Street was somewhat luckier. His family was able to escape his wrecked home and while "his motor garage was blown from the yard and smashed to slivers, his car stood on the floor, uninjured, and he was able to take it out after the storm and proceed with the work of rescue."[12]

For eight Regina residents living in this area, however, the tornado brought death rather than escape from the devastation.

One of the casualties was Fred Hindson, described as either a medical student or a recent pharmacy graduate who had returned to his parents' home at 2220 Lorne Street to work for the summer. His father James described his son's death to reporters:

When I realized the enormous proportions of the storm about to strike us, I called to the children to run to the cellar. I also shouted from the centre of the house for Mrs. Hindson and Bob Edgar, who were in the front of the house on the ground floor. They, however, apparently did not hear me. Fred, Douglas and myself were near the entrance to the cellar when the full force of the storm hit the house, and it immediately crumbled.

The rest of the Hindson family survived, with James badly cut and bruised and his wife physically unharmed but with no recollection at all of the storm itself, remembering only waking in the ruins of her home with her son Bob Edgar over her "acting as a shield."[14]

The Guthrie home at 2138 Lorne Street was the site of two deaths. One casualty was Etta Guthrie, daughter of the widow who owned the home. She was at first identified by rescuers as only a young girl with an engagement ring on her finger.[15] Also found injured in the wreckage were two roomers, Mr. and Mrs. F. W. Harris. She was taken to hospital where she died soon after, and he was carried to a temporary shelter set up in the Roman Catholic Bishop's Palace on McIntyre Street and recovered enough to take his wife's body to Brandon for burial two days later.[16]

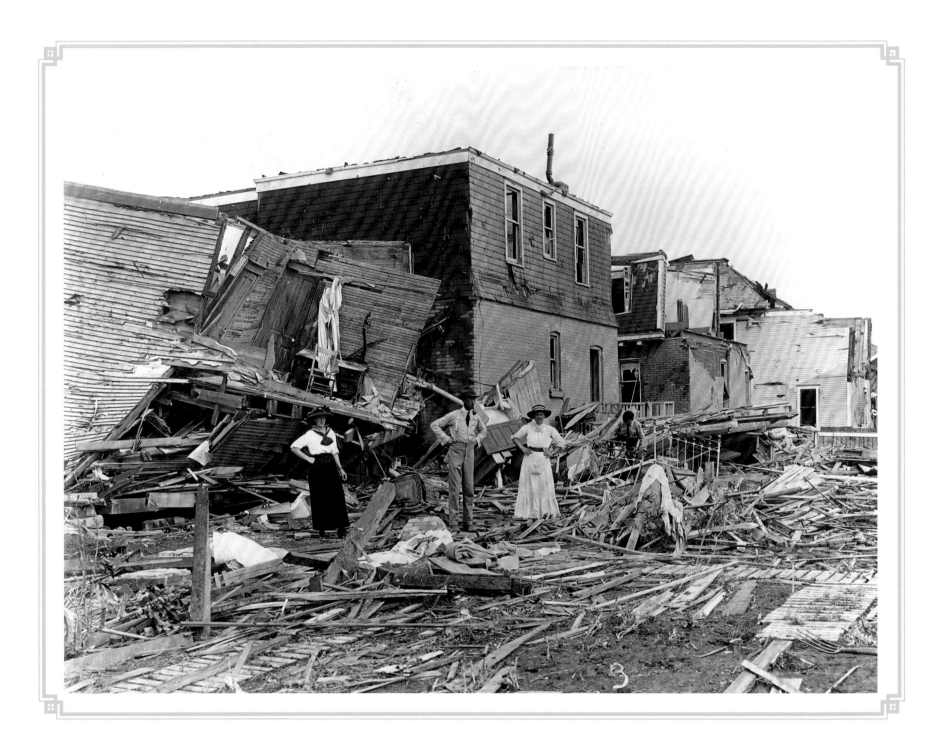

FACING PAGE: Also on Smith Street was the home of Regina Exhibition manager H. C. Lawson, who described himself as the owner of a $13,000 pile of rubble.

Another death occurred at the Chinese laundry located on the corner of Smith Street and 13th Avenue. When civic worker Alex Houston arrived there, he noticed a crowd of Chinese men "very excited," looking at their countryman whom they thought had died in the wreckage of the building. Houston thought the victim, Ywe Boyuen, was injured rather than dead but the Chinese would not assist in rescuing him because "they thought he was dead and they will not touch a dead body."[17] By the time he was removed, Boyuen had succumbed to his injuries.

Two men who boarded at 2202 Lorne Street were killed when this house, according to the *Province*, had its walls "simply ground to powder. It is levelled to the ground and how anyone could have escaped from the structure is one of the many marvels of the catastrophe."[18] James Patrick Coffee of Ireland was taken dead from the rubble and retired farmer Andrew Boyd was so seriously injured that he died in hospital two days later.[19] Survivor Kenneth Reid described the terror he experienced when the storm struck this house:

ABOVE RIGHT: On the corner of 15th Avenue and Smith Street, the storm blew out all the windows and drove a plank sixteen feet long through the upper floor of the home of J. F. Anderson.

RIGHT: This view looking south along Lorne Street appears to have been photographed from the damaged roof of the First Baptist Church. It shows the throngs of people who took to the streets after the tornado to survey the damage.

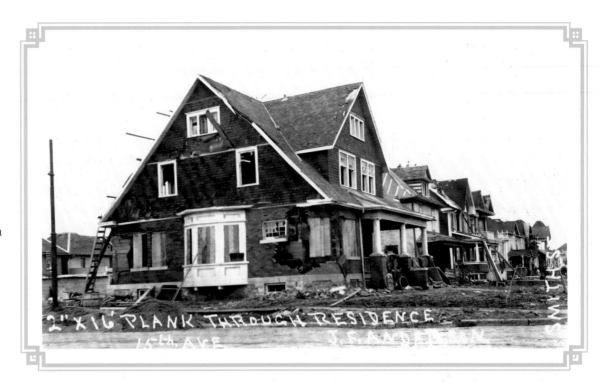

2" X 16' PLANK THROUGH RESIDENCE
15th AVE. J. F. ANDERSON SMITH

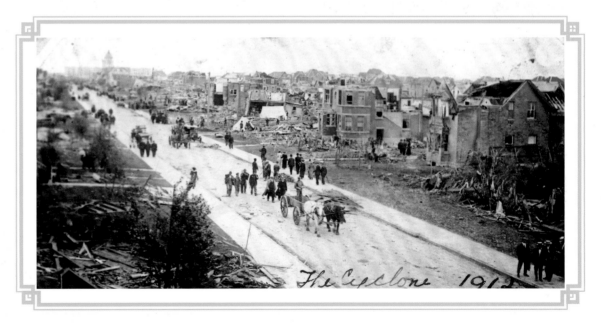

The Cyclone 1912

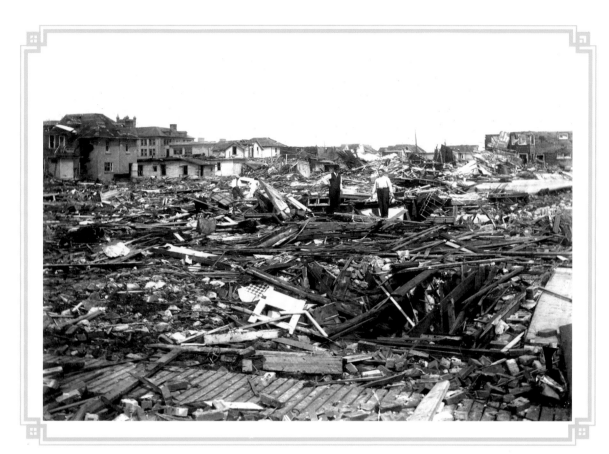

LEFT: This photograph shows the massive destruction on Lorne Street, perhaps near 13th Avenue, as the building in the background to the left appears to be Victoria School.

I was in my room when the house first began to rock. It reminded me of a ship at sea. Then it started to twirl round and round and I was hurled from wall to wall and tossed about like a plaything. I am sure that I struck all four walls before I finally lost consciousness.[20]

Paul McElmoyle had to endure the shock of seeing his wife killed as the two of them rushed to get their children to safety under their store on 14th Avenue. He told a *Province* reporter:

We were trying to get into the cellar after seeing that the storm had taken such large dimensions, and, with my wife, I was within one second

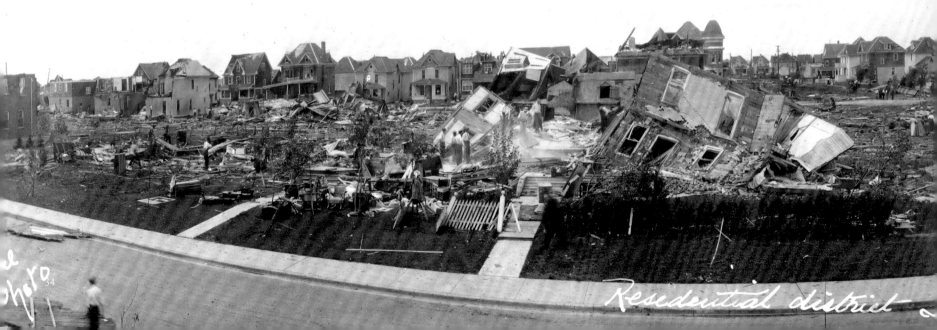

Resedential district

of being safely in the cellar beneath our little store. I was horrified to see my wife fall, struck by something, and myself made helpless to render any assistance to her by the debris which was piled all around me. It is indeed a very hard loss to bear, with three motherless small children."[21]

The 2200 blocks of Smith and Lorne streets, between 13th and 14th avenues, were among the worst hit, with "homes wiped out of existence and hardly a wall left standing."[22] Surprisingly, however, there was only one casualty in this area—baby Donald Loggie who was killed when the storm hit his parents' home at 2201 Smith Street.

In less than five terrifying minutes, the tornado completely changed Regina's best residential neighbourhood. Eight blocks of Smith and Lorne streets were left with almost no habitable houses, with homes and small businesses on the avenues which crossed them and residences on adjacent McIntyre and Cornwall streets also damaged. Personal property littered the area, usually badly damaged but occasionally with fragile items like lanterns or dishes quixotically left intact. Even more serious were the injuries and loss of life suffered by the people of the area. Eight individuals were killed by collapsing structures, some dying immediately and others within a few days. An unknown number suffered injuries, many of which required treatment in the city's suddenly overwhelmed hospitals. Even those uninjured physically were shaken emotionally by what they saw and felt as their world literally shook and whirled about them. ❖

BELOW: This panoramic photograph by professional photographer E. C. Rossie shows the destruction along two blocks of Lorne Street. At the far right are the ruins of Metropolitan Methodist (now Knox Metropolitan) Church and just to the right of the pole is Victoria School which served as a refuge for some storm victims.

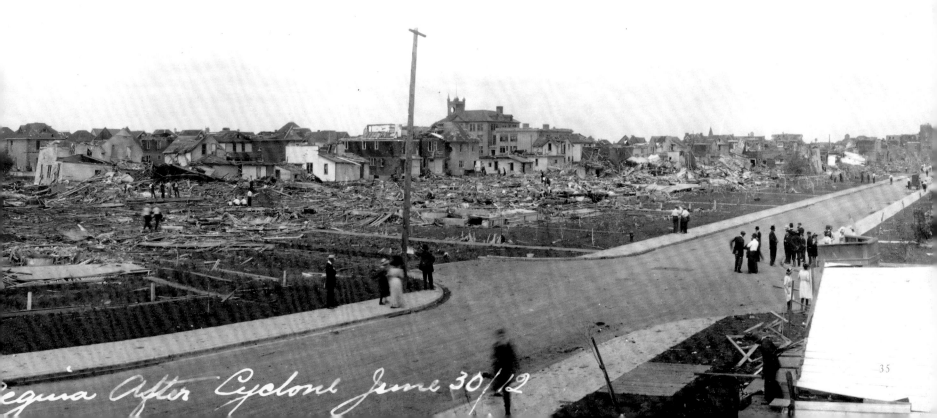

35

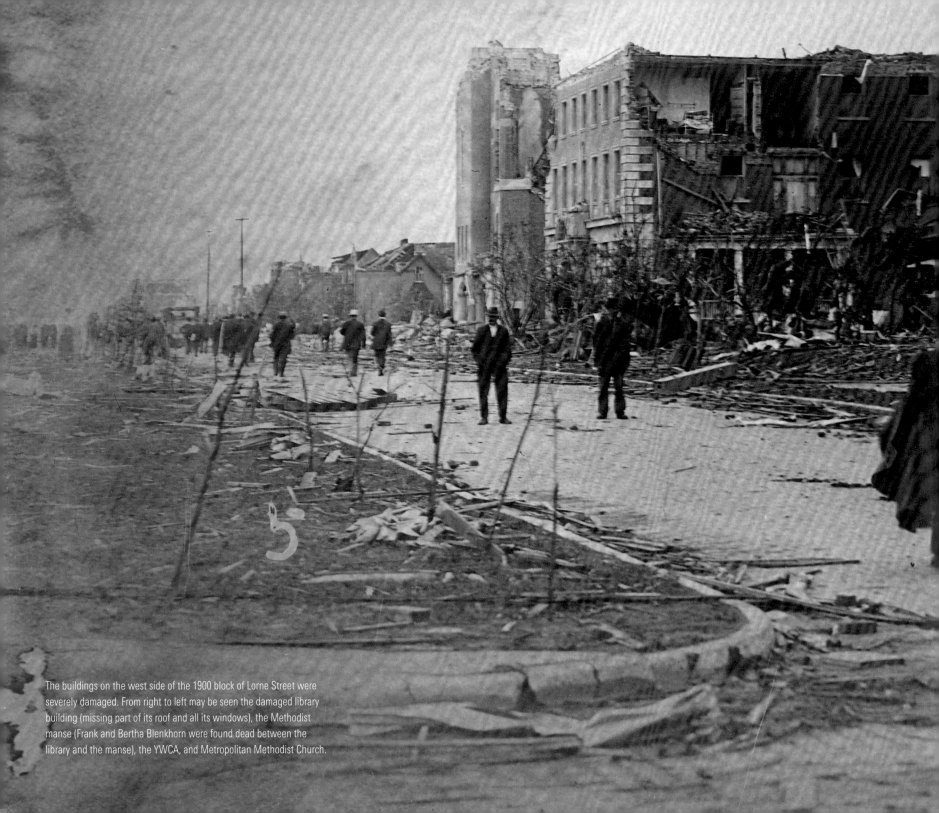

The buildings on the west side of the 1900 block of Lorne Street were severely damaged. From right to left may be seen the damaged library building (missing part of its roof and all its windows), the Methodist manse (Frank and Bertha Blenkhorn were found dead between the library and the manse), the YWCA, and Metropolitan Methodist Church.

CHAPTER 5

IN AND AROUND

Victoria Park

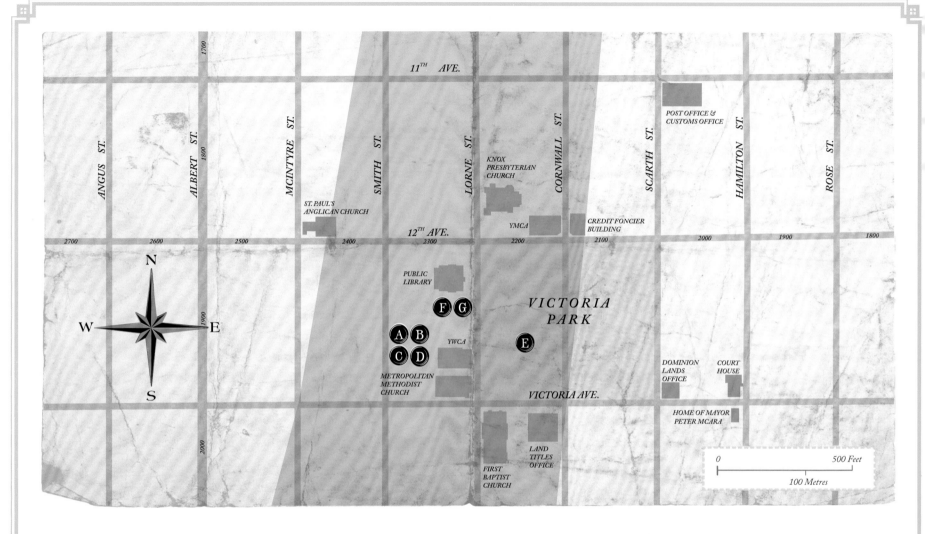

Victoria Park

■ —PATH OF THE TORNADO

FATALITIES:

Ⓐ *Lawrence Hodsman*—1947 Smith Street

Ⓑ *Isabelle McKay*—1947 Smith Street

Ⓒ *Charles McKay*—1947 Smith Street

Ⓓ *Arthur Donaldson*—1947 Smith Street

Ⓔ *Mary Shaw*—Victoria Park

Ⓕ *Frank Blenkhorn*—1900 block of Lorne Street

Ⓖ *Bertha Blenkhorn*—1900 block of Lorne Street

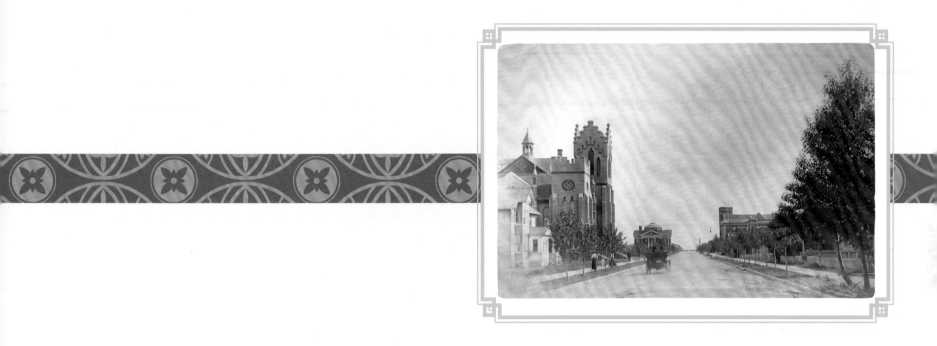

After crossing Regina's southern residential area, the tornado then struck at the heart of the city. Victoria Park was located on two square blocks bordered by Scarth and Lorne streets and Victoria and 12th avenues. City fathers had recently begun a plan to beautify the park with a fountain, paths and newly planted trees. Also, surrounding the west end of the park were newly constructed public buildings, including the land titles office, three large churches, both the Young Men's and Young Women's Christian Associations, and a public library. However, the area was also home to many citizens living in private homes and rooming houses.

ABOVE: Before the storm, the 1800 and 1900 blocks of Lorne Street were considered to be the most attractive in the city, with (from left to right), Knox Presbyterian, First Baptist, and Metropolitan Methodist churches. However, as the following photographs in this chapter show, the tornado drastically altered this landscape.

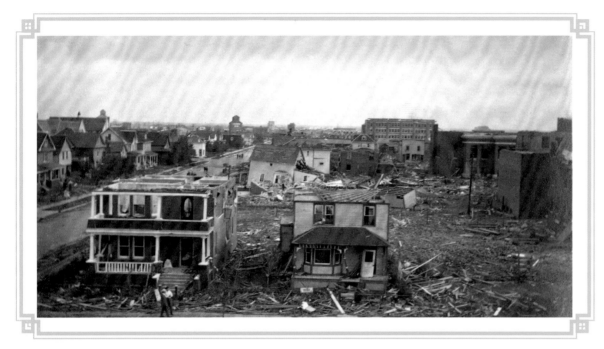

One of these houses, at 1947 Smith Street, was the site of four deaths. The home owner, James Hodsman, miraculously was uninjured although his wife told reporters that he "was carried right from the top floor downstairs and he didn't even get a scratch."[1] However, she and her young son Reginald were both hurt badly enough to require hospitalization, and an older son, Lawrence, was killed. The Hodsmans had roomers in their house, two of whom were killed and the rest sent to hospital. Among the dead were Mrs. Isabella McKay and her three-year-old son Charles. The fourth casualty was Arthur Donaldson who, accompanied by his dog, had rushed up on the porch just as the storm hit and the front wall of the house collapsed on him. The dog was blown away by the wind but returned to the ruin as rescuers worked to remove the dead and injured. It then followed its master's body to the funeral home where it kept vigil for four days.[2]

Some of the residents in this area were clergymen and their families living in manses near their churches. One of these was Methodist pastor Reverend J. Lewis who lived on the 1900 block of Lorne Street between the public library and the YWCA, in a home facing Victoria Park. He had to rescue his invalid wife from her bed in the upstairs sun room as the storm struck. The *Province* recorded their experiences:

Mr. Lewis rushed and grabbing her in his arms, took her out just as the room collapsed. She would have been killed instantly in her bed. Mr. Lewis carried her in his arms towards the back entrance with the whole house flying around him. He could not get out and then made for the entrance. This was also blocked. Holding Mrs. Lewis in his arms, Mr. Lewis sat on the stairway while they waited for what they expected would be instant death. They expected to die in each other's arms.[3]

The Lewises were, however, among the lucky ones who survived relatively unhurt.

The manse for Knox Presbyterian Church, at 1839 Lorne Street, was the home of the family of Reverend Murdock MacKinnon, and it too suffered extensive damage. His wife Lillian, at home with a three-week-old daughter and several members of her family when the storm struck, wrote an account of the family's experience. Her brother-in-law Hugh had gone upstairs to close windows, but they blew out as he touched them and the roof lifted off. Hugh then tried to escape:

He doesn't know to this day know how he got downstairs. But the moment he was out of the house he was caught up and hurled away down the street. He was hit by chunks of wood and bits of brick, and lay there buffeted until he lifted his head, saw the roof, then the windowless house. He thought we had all been killed. He let out a great cry in Gaelic which I can hear even yet![4]

He later rushed into the ruined house to find his family alive and able to bandage his bleeding head with strips torn from his wife's petticoat.

LEFT: This substantial home of Norman Mackenzie, with the white pillars, on the corner of Victoria Avenue and Smith Street suffered substantial damage, while the one behind it at 1947 Smith Street collapsed completely killing four people.

The rest of the MacKinnon family had managed to survive the storm by sheltering each other. Lillian MacKinnon later explained this to her granddaughter:

Where were we? All hugging together near the front bay window—the only window which wasn't smashed, for you see it was protected by a porch. Your grandfather had his dear arms around Emma and me with the infant in my arms and wee Catherine between his knees.[5]

Once Reverend MacKinnon was sure the storm was over and his family was safe, he went with a neighbour to help rescue others, and the rest of the MacKinnons were taken to the undamaged home of a parishioner which sheltered 12 people for the night.

As in other parts of the city, people were in danger from moving debris as well as collapsing buildings, as the experiences of the Waddell family of 1756 Cornwall Street illustrated. The *Leader* told of their experience:

Just as the storm of wind and rain struck the house, the horror of the situation was added to by a runabout Cadillac automobile crashing through the front wall right into the parlour, where, after striking the opposite wall, it bounced back into the street again. In its wild flight through the room the machine just missed Mrs. Waddell by an inch.[6]

RIGHT: Beside Knox Presbyterian, the YMCA had nearly half its building collapse, while the Credit Foncier building across the street to the east suffered little damage.

Located on the north side of Victoria Park on the corner of 12th Avenue and Cornwall Street, the Young Men's Christian Association (YMCA) provided both accommodation and recreation for both visitors and citizens of Regina. This relatively new building, constructed in 1907, was three stories high and had about 50 rooms, most of which were empty as the tornado struck because the men staying there had gone out seeking relief from the heat. T. H. Williams of Galt, Ontario, was in his room and shared his experiences with a reporter:

G. Tierman and myself were in room twelve. We had both been reading and had fallen asleep on our beds. I was wakened by the rattle of rain on the windows. The noise was so terrifyingly loud that I jumped up in bed to look out. I saw over the park buildings flying in the air, and we flew to our feet to make a rush for the lower floors. We had hardly reached the entrance when the whole building shook like a leaf and appeared to tumble about our heads. That was the last thing I remembered until I awoke to find myself on the ground pinned under a mass of wreckage, far removed from the building. How I could ever have been hurled so far is impossible to imagine. A big timber was folded and bent like a match and sustained the weight of the brick partition which would have otherwise crushed out our lives. I am not badly injured and my friend never even had to go to the hospital. When we were released at the end of about fifteen minutes Mr. Tierman started out to see the sights and help in the work of the rescue.[7]

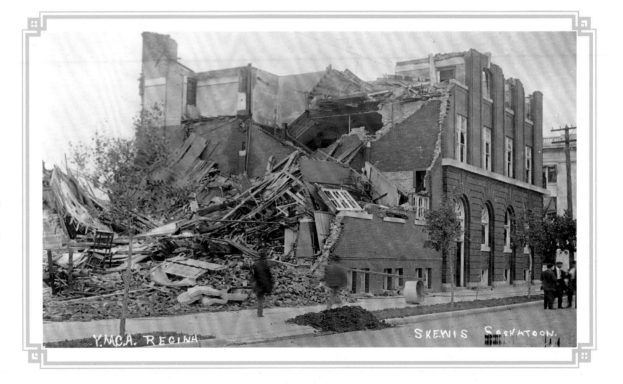

Y.M.C.A. REGINA. SKEWIS SASKATOON.

In another part of the building, 13 men had just completed their regular Sunday afternoon Fellowship service. The meeting leader, Mr. Sibbald, described the impact of the storm:

The service was just completed but we had not dispersed, when the cyclone struck us. The room today looks like a slaughterhouse. The walls and ceilings are bespattered with blood. Every window has been carried out bodily and the massive doors carried from their frames and splintered into a thousand pieces. Yet not one of the thirteen young men in the room has been seriously injured, although all are battered and cut.[8]

The *Province* article which carried this report ended with the following comment: "Today the thirteen are trying to figure out whether it is an unlucky number or not."[9]

Other parts of the YMCA building suffered extensive damage as the *Leader* reported:

The building is a complete wreck with the exception of the first floor and the swimming pool. The roof was lifted from the building and the walls of the top story destroyed. On the ground floor while the walls are still intact the interior is a mass of wreckage and the furnishings destroyed beyond repair.[10]

In its estimate of losses, the *Standard* gave the figure of $50,000 for this building which it described as "partially destroyed."[11]

The YWCA, located across from Victoria Park on the 1900 block Lorne Street, was also in the tornado's path. This building, which had been opened only a few months earlier, had room for 60 residents. When the storm hit, it blew out windows and knocked down both stone and brick walls, doing damage which the *Standard* estimated at $60,000.[12] The *Leader* carried an extensive report of the experiences of some of the residents:

Up on the third floor are scenes of very narrow escapes. Amongst those who had the closest calls and escaped without scratches are the Misses Broderick. They were in their bedroom in the northeast corner, lying on their bed which was close up against the north wall when the roof was torn off, carrying with it a great section of the wall. The bed was hanging over the side and the least jolt would have overbalanced it. One sister slid off the south side, pulling her sister after her.

Another miraculous escape was that of Miss Nellie Henry, sister of the Travellers' Aid secretary. She was in her room and was seized with terror, rushing into the clothes closet and shutting the door after her. Scarcely had she done so, when a great timber was hurled through the window, twisted to the right and crashing into the door leading in to the hall, broke it off its hinges.

Miss Bowers and Miss Donaldson had just come in for tea and were removing their hats in the cloak room on the first floor, when bricks came flying down through the skylight, falling on top of them. Under the

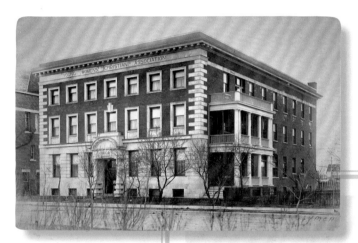

ABOVE: The YWCA before the storm.

LEFT: This photograph of the south end of the1900 block of Lorne Street shows walls and windows missing from the YWCA in the foreground, damage to the towers of Metropolitan Methodist Church behind it, and the missing dome of First Baptist Church across the street (left-hand side of picture). Bricks and other debris from these buildings litter the road.

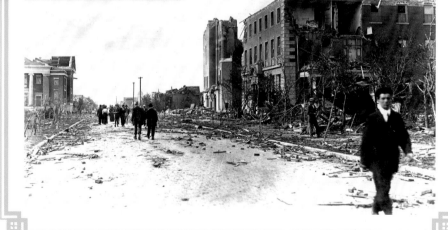

circumstances, it is rather remarkable that Miss Bowers did not have more than a broken thumb and crushed arm.[13]

The 1900 block of Lorne Street was also the site of Regina's public library, which had been open to the public for less than a month. As described by library board chairman Canon G. C. Hill, "the building being of reinforced concrete, brick and stone, withstood the force of the storm admirably, but the terrible wind and drift of debris went right through the windows destroying the roof entirely and doing a great amount of other damage."[14] Some of the "other damage" was to some books in the library, which Lillian MacKinnon noticed on Lorne Street, "soaked and torn lying face down, backs broken."[15] However, the majority of the books were rescued because library staff and volunteers moved them to the main floor of the building where the wind and rain could not damage them.[16]

First Baptist Church, on the southeast corner of Victoria Avenue and Lorne Street, was one of the three churches heavily damaged by the tornado. Its minister, Reverend S. J. Farmer, had been in the building during Sunday School sessions but decided he would go home for tea before returning for the evening service. He was very grateful that neither he nor anyone else was in the church when the

PUBLIC LIBRARY
PUBLIC LIBRARY

These photographs show the newly opened Regina Public Library before (BELOW) and after (LEFT) the tornado. The structure lost its windows and part of its roof, but the building itself remained standing.

tornado struck.[17] The vicious winds tore off the dome or cupola from this recently completed building and carried it for two blocks. It landed on the roof of another church, Saint Paul's Anglican on 12th Avenue and McIntyre Street, where parishioner D. M. Woodhams remembered that it "slid down our sharp roof there, and it made such an awful row."[18]

Diagonally across Victoria and Lorne from the Baptist church was Metropolitan Methodist, which suffered more extensive damage but miraculously no loss of life. Although there had been over 300 children in Sunday school the afternoon of the storm, they had all left, leaving only Matthew Henderson in the building:

I was in the club room at the rear of the church when the storm broke. I ran to leave the building when I saw bricks flying through the air, through the door and windows. Then I ran back to see if anyone was in the main body of the church. I started madly to the Sunday School room, it was empty. The noise was absolutely as if the world was coming to an end. I ran back to the rear entrance

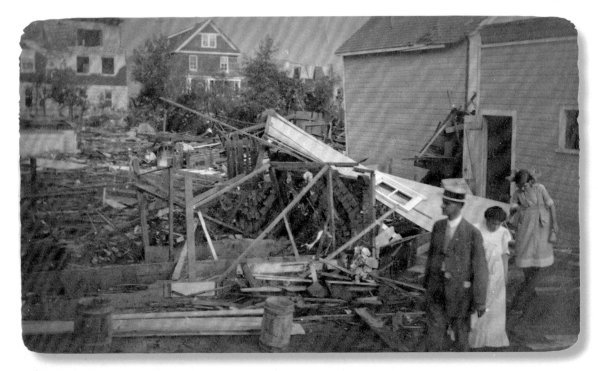

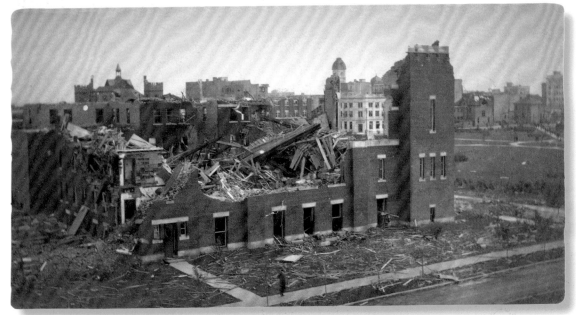

TOP: Businessman Henry Laird surveyed the wreckage in the back yard of his home on Victoria Avenue. The damage to the back of First Baptist Church can be seen in the background to the left.

BOTTOM: This photograph, with Victoria Avenue in the foreground and Victoria Park to the right, shows the extensive damage to Metropolitan Methodist Church.

and attempted to open the door. The wind was blowing so strongly, I hesitated with it partly open. Placing my knee against the door, I stood a fraction of a second. The whole side of the church collapsed and fell in front of me, brushing past me by a hair's breadth with a mass of stone, brick and timber. I then crawled out over the door that acted as a shield over the ruins of the church."[19]

The *Leader* described the damage to this building as "the most complete wreck of all. The main entrance and a small portion of the wall is all that remains of the front of the building. The south wall and extension is gone with the exception of about eight feet of brick. This building will have to be entirely rebuilt."[20]

The third church facing Victoria Park was Knox Presbyterian, on the southeast corner of Lorne Street and 12th Avenue, which was also extensively damaged, as the *Leader* reported:

The stately tower is almost entirely carried away and the wall facing the park is flattened. The large windows were apparently carried away with the first gust and this allowed a large part of the wind to rush through the window leaving the walls at either end of the church partially standing.[21]

As the storm threatened the city, several residents were crossing Victoria Park headed for their homes. As conditions worsened, they

decided to seek shelter in whatever building was nearby. One of these was D. L. Stewart:

With all haste he made for the doorway of the Presbyterian church. Having got there, Mr. Stewart pressed himself hard up against the door to resist the suction of the wind, which was pulling at him desperately. Just as he thought the worst was over, the roof of the church fell in with such force that the door up against which he was leaning was thrown out into the middle of the road, taking Mr. Stewart with it, where he fell amongst a shower of bricks. Very luckily he escaped without any bones being broken. He was not even knocked unconscious, but his legs and arms were cut in a dozen or more places, and he was bruised from head to foot by the fall.[22]

Law student E. St. James had a very similar experience outside Metropolitan Methodist Church where he headed for safety from Victoria Park. "He stood in the porch alongside one of the large pillars all through the storm, and although the building fell in ruins at his feet, he, himself, escaped uninjured except for a couple of small cuts on the head from the falling bricks, which just grazed him."[23]

Some of those in the park were not so lucky. One woman who was found badly injured in Victoria Park and died shortly after being taken to the General Hospital was Mrs. Mary Shaw. She and her husband lived on 12th Avenue, just east of the park, so presumably she was on her way home when the storm struck.[24]

Frank and Bertha Blenkhorn, recent immigrants from Britain to Regina, where he had just started his own real estate business

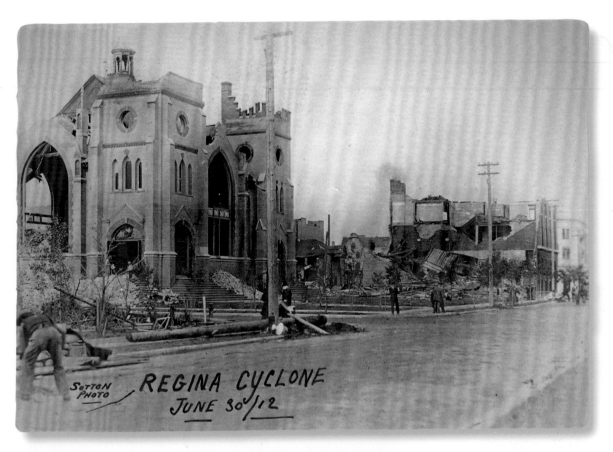

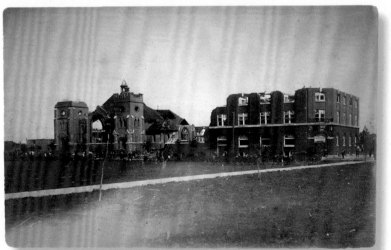

TOP: On the north side of Victoria Park on 12th Avenue, Knox Presbyterian Church (left) lost its windows and suffered much damage to the interior. The extensive damage to the YMCA can be seen on the right.

BOTTOM: This photograph, taken across the north side of Victoria Park, shows the damage to the same two structures from another viewpoint.

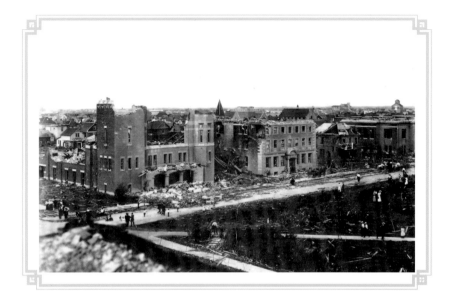

ABOVE: This view of the west side of the 1900 block of Lorne Street was likely photographed from the roof of the Land Titles Building.

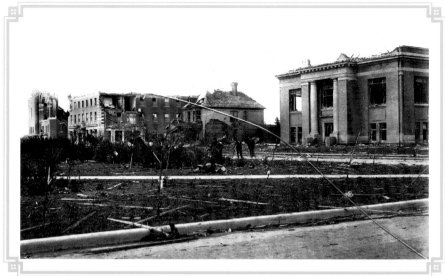

ABOVE: The buildings on the west side of the 1900 block of Lorne Street were severely damaged as is shown in this photo. From right to left may be seen the damaged library building (missing part of its roof and all its windows), the Methodist manse (Frank and Bertha Blenkhorn were found dead between the library and the manse), the YWCA, and the Metropolitan Methodist Church.

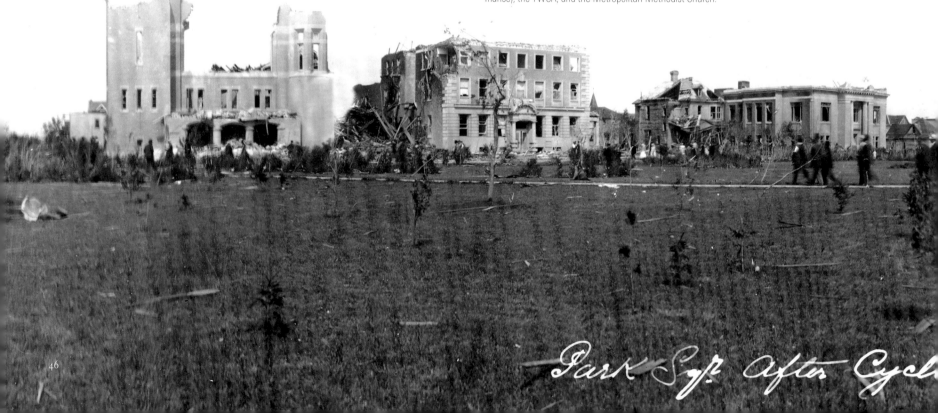

Park Sq. After Cycl

after working for the *Standard* selling advertising, were also crossing the park at the time the storm hit. Unlike some others, they were unable to reach safety. Apparently they were blown across both the park and Lorne Street and "hurled against one of the brick structures facing on Lorne Street, and were probably instantly killed."[25] Then, debris from the Methodist manse just south of the library fell on them. Their bodies were found just after the storm by rescuers. Their situation was made ironically tragic because he at least had escaped death just three months earlier. He had booked passage on the maiden voyage of the *Titanic* but had missed the ship's sailing. Some histories of the storm claim that this trip was in fact to be their honeymoon but they had so long at their wedding celebration that the ship had already left port.[26]

The damage to buildings near the western end of Victoria Park was extensive, but those just a few metres further east remained relatively unscathed. The Land Titles Building on Victoria Avenue next to First Baptist Church suffered only damage to the roof and broken windows. So did the Credit Foncier building on 12th Avenue, just across Cornwall Street from the badly mangled YMCA.

Thus, in a matter of seconds, the scenic heart of Regina, often featured on postcards and pamphlets advertising the city, had been reduced to a pile of rubble. Three churches, the public library and both the YM and YWCA had suffered enough damage to render them unusable and needing significant expensive and extensive repairs. Many homes in the area were also destroyed, many people were injured, and seven Regina citizens had lost their lives there.

The timing of the storm, late Sunday afternoon, kept the number of casualties much lower than it would have been either earlier or later in the day, when the churches would have been filled with worshippers. ❖

BELOW: This panoramic photograph of the Victoria Park area shows the damaged buildings to the west and north of the open area, with (from left to right) Metropolitan Methodist Church, the YWCA, the Methodist manse, the public library, Knox Presbyterian Church, and the YMCA. The buildings at the right of the photograph, from the white Credit Foncier building on the east side of Cornwall Street, are almost completely intact.

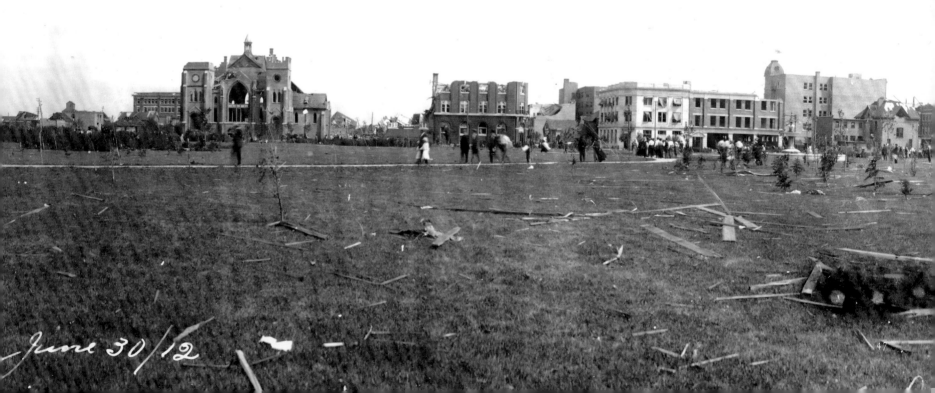

June 30/12

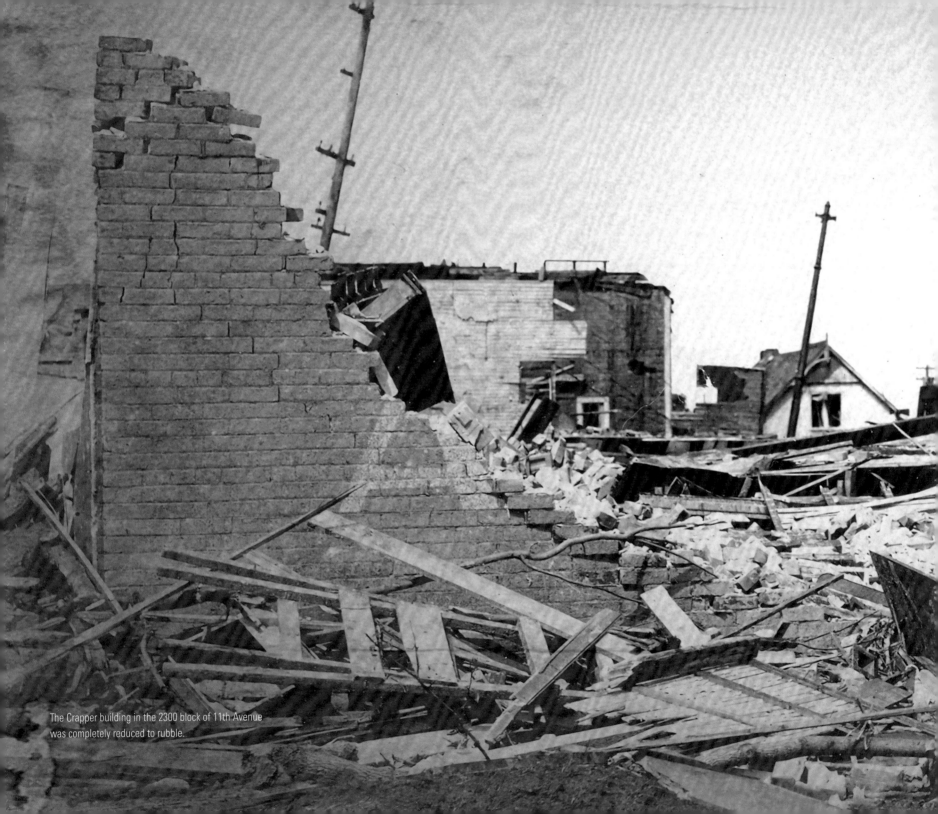

The Crapper building in the 2300 block of 11th Avenue
was completely reduced to rubble.

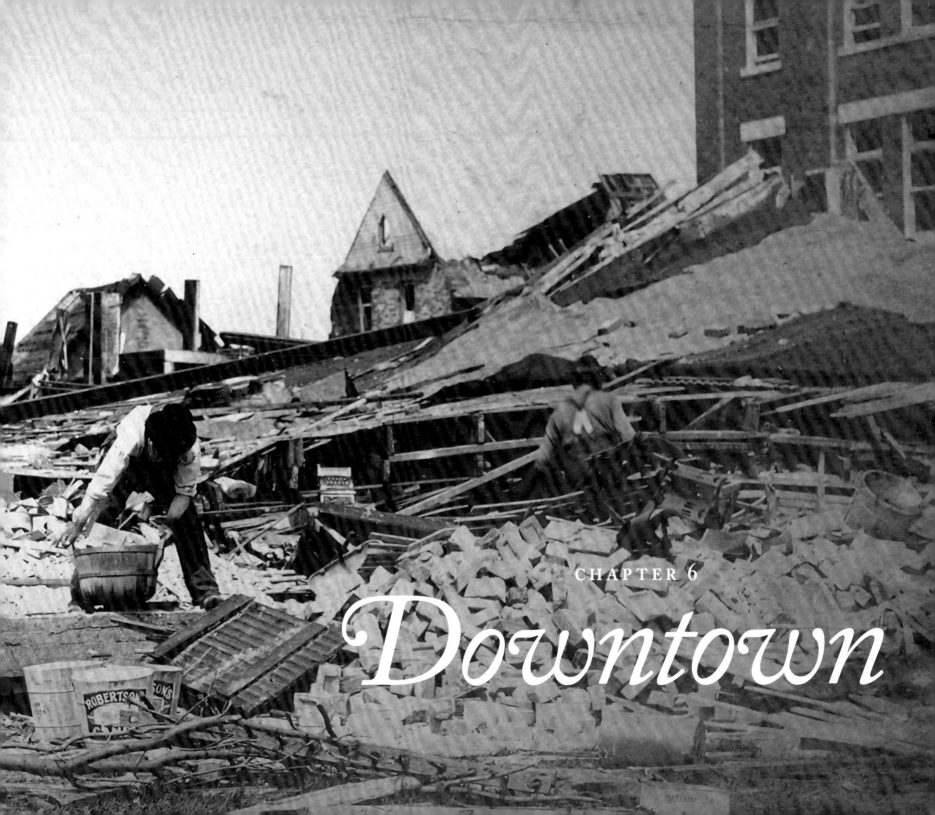

CHAPTER 6

Downtown

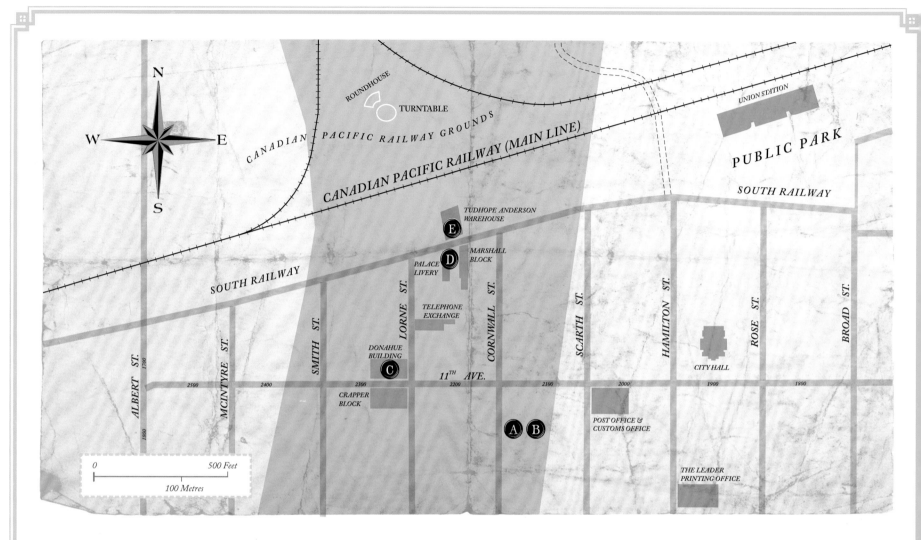

Downtown

■ —PATH OF THE TORNADO

FATALITIES:

Ⓐ *Charlie Sand*—1821 Cornwall Street

Ⓑ *Ye Wing*—1821 Cornwall Street

Ⓒ *James Milton Scott*—Donahue Building, 11th Avenue & Lorne Street

Ⓓ *Robert Fenwick*—Palace Livery, 2223 South Railway

Ⓔ *Joseph Bryan*—Tudhope Anderson, north side of South Railway between Cornwall & Lorne streets

Continuing to move north from Victoria Park and veering a little east towards Cornwall Street, the tornado hit Regina's downtown business core. There it damaged both large and small structures, both residential and commercial, and again inflicted injuries and death.

One building completely demolished was the government telephone exchange on the east side of the 1700 block of Lorne Street. The *Leader* described the impact of the storm on the two-storey brick building:

The building shuddered and shook for an instant, then the roof ripped loose, and the south wall crashed in, flattening the building to a heap of twisted timbers and shattered bricks.
Underneath were buried some ten human beings, imprisoned beneath walls and floors.
A heavy switchboard crashed through into the basement where a man was working, carrying three girls with it. The four escaped through a basement window and carried the news to The Leader Building where their hurts were attended to, and whence a party immediately started out to commence the work of clearing the debris and releasing those who were imprisoned beneath it.[1]

As the 15-ton switchboard went through the floor to the basement below, it carried three of the operators, still wearing their headphones, down with it, where they were buried in the rubble along with others who had rushed to the lower level to escape the storm. Somehow there was also a bull dog in the debris.[2]

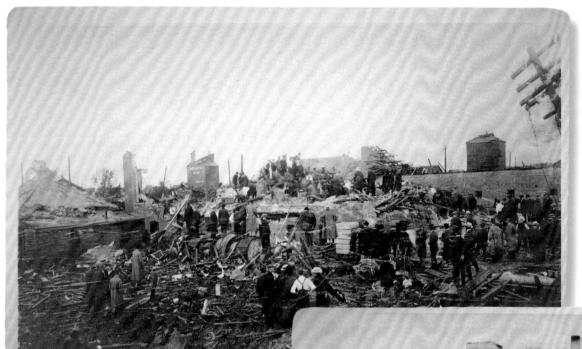

RUINS OF TELEPHONE OFFICE

convinced that the telephone exchange building had in fact collapsed, they formed a rescue party.

The rescue efforts attracted many and lasted several hours. The entire printing and editorial staff of the *Leader* rushed to the building to start the search for victims, and over a hundred others joined them as word of the disaster spread. One of these was Reverend Murdoch MacKinnon, who lived nearby. His wife

Storm historian Frank Anderson claims that the men at the *Leader* first reacted with disbelief when the operators arrived with their request for assistance: "At first their story was treated with jocular good humour and they were kidded about 'trying to get their names in the paper'."[3] Even though the Leader Building was at 1853 Hamilton Street, just two blocks from the main path of the tornado, the reporters had obviously not grasped the emergency situation. However, once they were

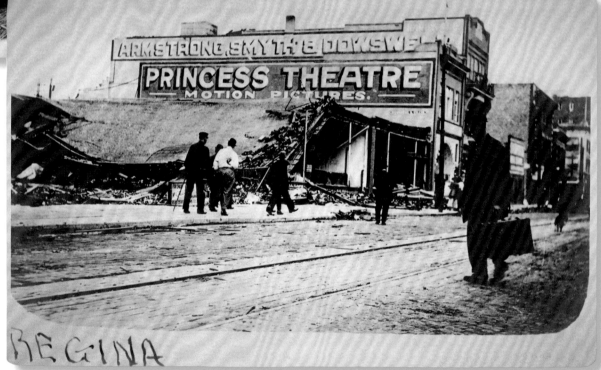

reported that just as the MacKinnon family was assessing the wreckage of their own home on Lorne Street, a neighbour came looking for an axe to use to help free the operators. MacKinnon joined his neighbour, spending several hours at the telephone exchange.[4] The *Province* quoted an unnamed rescuer, a guest at the King's Hotel, who described the final part of the rescue:

Then I hurried to where the telephone girls were buried. All had been rescued but two. Their voices could be heard in the ruins. The crowd raised its hands for silence so that their voices might be heard. In an awful silence the workers labored while the two girls calmly gave instructions. They seemed more composed than the rescuers or the crowd, and when they were finally lifted out women fainted, strong men wept and a mighty cheer swept the throng.[5]

Astonishingly, not one of the 11 people who were in the building when the tornado hit was seriously hurt.

Smaller buildings also were completely destroyed, sometimes with disastrous consequences. The Mah Chang Sing Chinese laundry at 1821 Cornwall Street was "instantly pulverized"[6] with three men, Ye Wing, Charlie Sand, and their brother Chan Sun trapped under the rubble. "Charlie Sand was dead when rescuers eventually reached them [the night of the tornado], Ye Wing lingered over the night at the General Hospital before he joined his brother in death; and only Chan Sun survived the terrible ordeal."[7]

Substantial buildings on 11th Avenue were also not immune to the storm's assault. The four-storey Donahue Building on the northwest corner of 11th Avenue and Lorne Street was damaged in spite of its steel construction, which saved the exterior walls but did not prevent interior damage. The ground floor of this structure housed several stores and offices including the Nordheimer Piano Company, Stemshorn's Flowers, Goodyear Rubber Company, Imperial Land company, Great West Fixture Company, and Armstrong, Gilchrist, Mason, which the *Province* described as a "gutted, total loss" with damage estimated at $30,000.[8] The upper floors of this building contained apartments, the residents of which reported that they felt the building "sway back and then with a snap spring back into place" when the wind hit it. Five men who were in a corner room on the third floor reported,

the roof was literally lifted from the walls, and then settled into place, while the electric light in this room attached to a cord was swung over the wall through the big crack, and when the roof settled back it held the light underneath.

A fyle [file] was found in the room after the storm which had papers in it showing that it belonged to

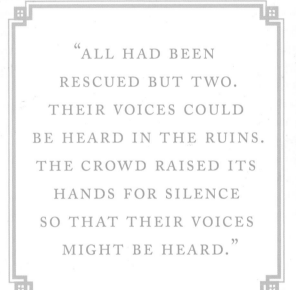

"ALL HAD BEEN RESCUED BUT TWO. THEIR VOICES COULD BE HEARD IN THE RUINS. THE CROWD RAISED ITS HANDS FOR SILENCE SO THAT THEIR VOICES MIGHT BE HEARD."

the Credit Foncier building a block away. The furniture in the room was blown into the next room.[9] In spite of this movement of the building, only one of the five in the room was injured, but another building tenant was not so lucky. James Milton Scott, a young clerk in the Customs Department who had recently moved there from another building, one which was not in the storm's path, was killed.[10]

Businesses in the Crapper Block, across the street from the Donahue Building, also suffered extensive damage. The *Standard*'s estimate of loss for its commercial tenants—Evan's Novelties, Yerxa's Groceries, Western Construction Company, and Crapper Paint Shop—was $45,000.

Two businesses on South Railway Avenue (now Saskatchewan Drive) were also the scenes of tragedy. One of these was a livery stable owned by W. H. Mulligan. He, his son, and several employees were in the building when it began collapsing and then was hit by falling bricks from the neighbouring Marshall Boyd Block. Robert Fenwick was killed instantly, but Mulligan was able to save several others, as he told a *Province* reporter:

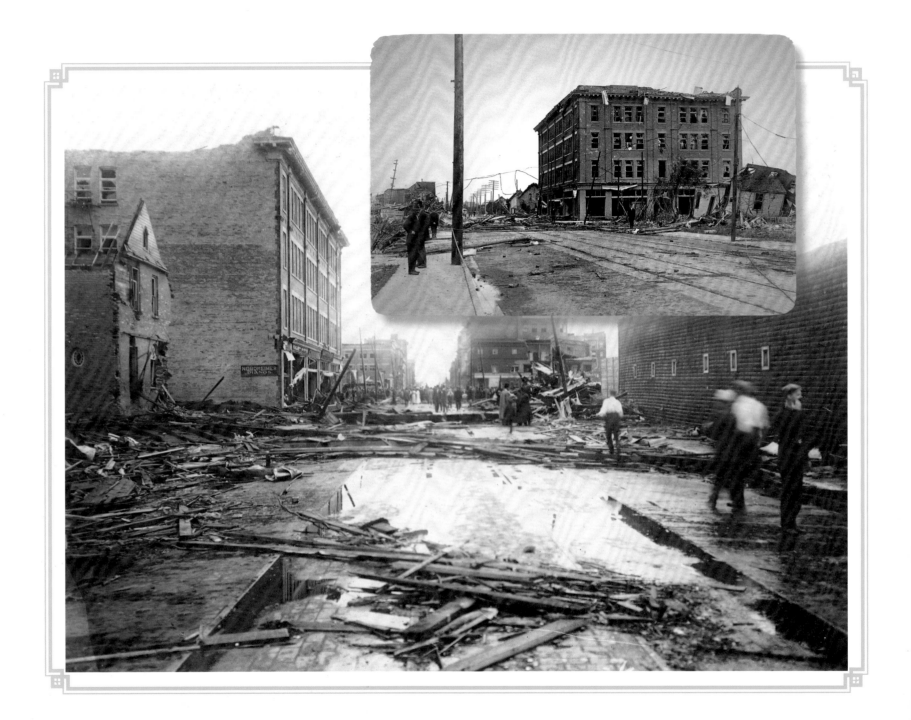

FACING PAGE : These two views of 11th Avenue looking east from Smith Street and west from Cornwall (inset) show the damage done to the substantial Donahue block where J. M. Scott was killed and the total collapse of smaller structures, the remains of which covered the road.

RIGHT: This is a page from *Regina: Before & After Cyclone, June 30, 1912*, one of the pamphlets printed to show people outside the city the extent of the damage. The remains of Mulligan's Livery are shown in the foreground.

BELOW RIGHT: The Masonic Temple, also on 11th Avenue, was likewise badly damaged in the storm.

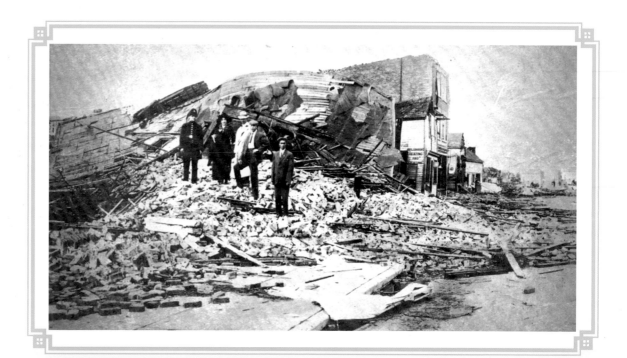

The first blast of wind carried a small boy, whose name is not known, hurling through the air into his arms. Mr. Mulligan held the boy in his arms while he and the others crawled from one part of the falling building to another in search of safety.[11]

When he finally made his way to the street, his thoughts of proceeding to his own home were interrupted when he heard screams coming from the destroyed building next door:

We all turned and went back, and I will never be able to forget the sight that met us. Standing buried to her chest in bricks stood a woman—whom I afterwards learned to be Mrs. Evans—holding high from the wreckage her infant child, practically uninjured while she herself was terribly bruised. We were finally able to extricate her from her terrible position, but it was a difficult task as we had to exercise great care.[12]

Fifty horses in the livery stables also escaped serious injury.[13]

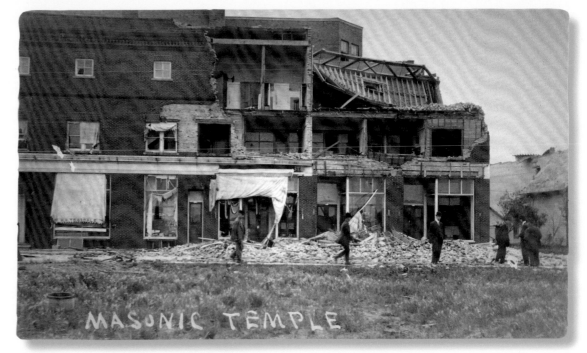

MASONIC TEMPLE

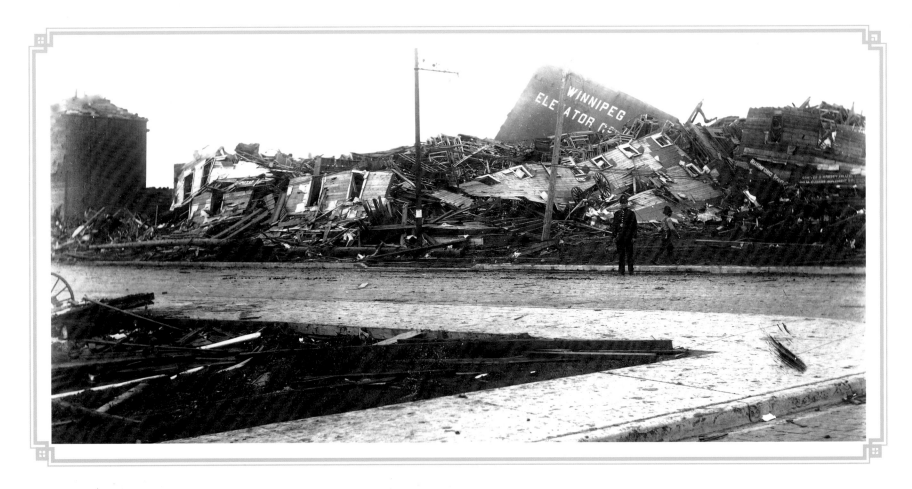

The Tudhope Anderson farm equipment warehouse on South Railway was also the site of a fatality. Joseph Bryan, manager of the Regina branch was meeting with one of the company's travelling salesmen, W. S. Ingram, who described his experience to a *Standard* reporter:

We were in the office and could hear and see that an extra heavy storm was coming in. Almost before we could think we were under this pile of wreckage. Mr. Bryan, who was near me, and thrown fairly on my back as I fell to the floor. Strange to say, I felt no injury, other than a somewhat dazed condition. I could feel that Mr. Bryan must be on me, and reaching up my hand could feel his body. I called to him, but received no reply, and reached up again to feel his arm. The body became limp, and I was quite sure he must have been killed.[14]

It took rescuers four hours to free Ingram from this building which had been completely reduced to rubble.

The damage from the tornado in this part of the city caused major disruptions to city businesses and services. The destruction of the telephone exchange led to predictions, later proved false, that telephone service would be unavailable for weeks or even months. Downtown businesses lost stock, buildings, and sometimes even employees, and thus faced interruptions in their operations. Also, as in other parts of Regina, many citizens found their homes damaged and sometimes completely uninhabitable. ❖

FACING PAGE: A police officer stands before the remains of the Tudhope Anderson warehouse where Joseph Bryan was killed, with the ruins of the large Winnipeg Elevator Company's grain elevator in the background.

THIS PAGE: Most of the buildings along South Railway (now Saskatchewan Drive) from Lorne Street west were demolished, as these four photographs show. The picture at the bottom left is looking north and shows the intersection of Lorne Street and South Railway with the CPR yards in the background; the remains of the government telephone exchange building are buried in the rubble at the far right of the photograph.

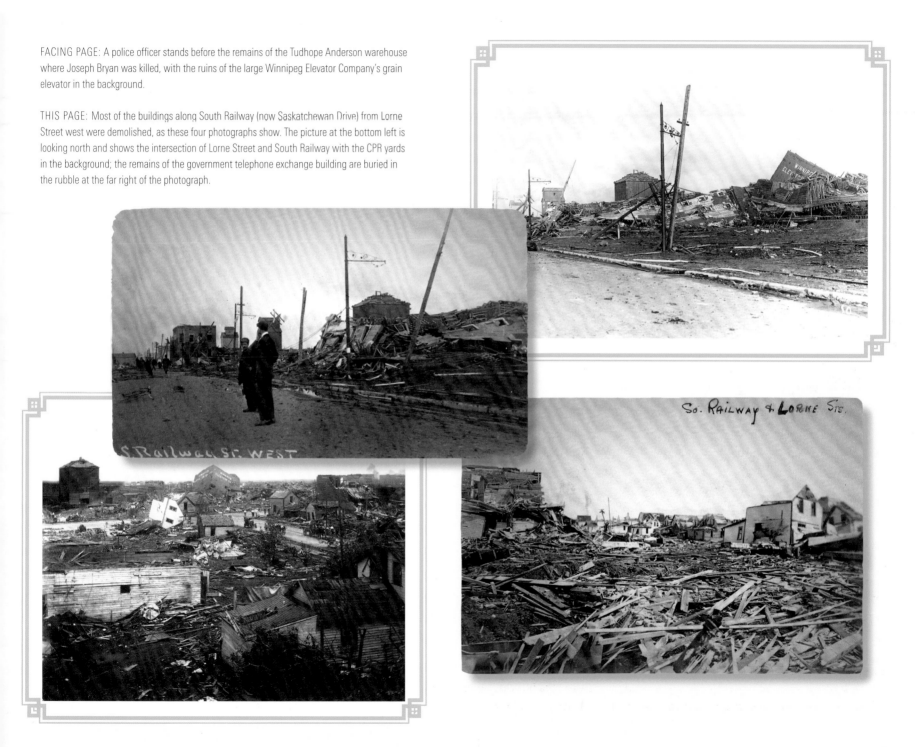

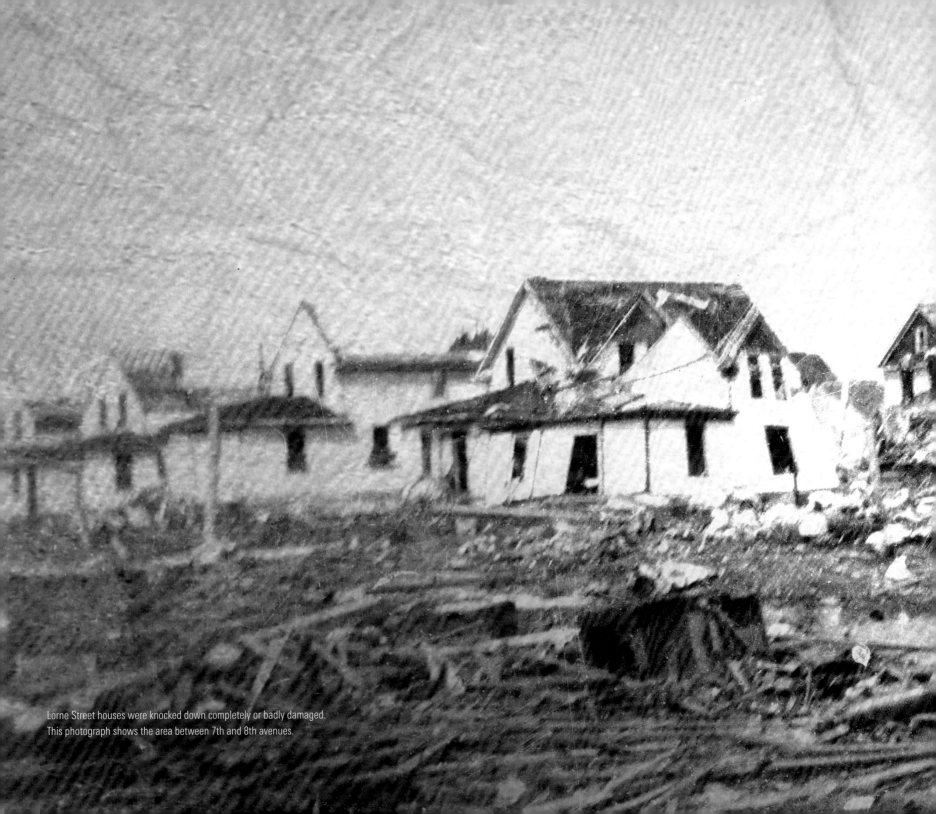

Lorne Street houses were knocked down completely or badly damaged.
This photograph shows the area between 7th and 8th avenues.

CHAPTER 7

THE *North Side*

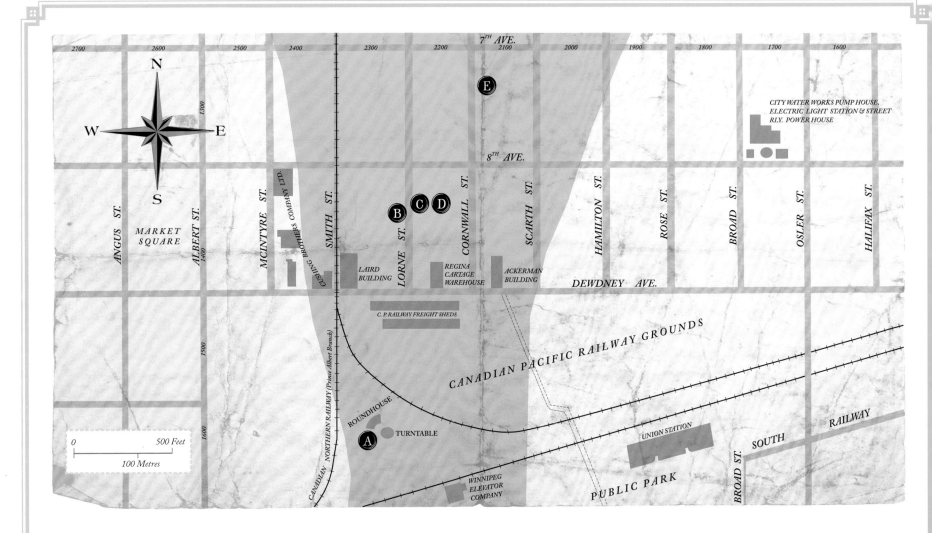

The North Side

■ —PATH OF THE TORNADO

FATALITIES:

Ⓐ *George Craven*—Near the CPR roundhouse

Ⓑ *Laura McDonald*—1438 Lorne Street

Ⓒ *James McDougall*—1435 Lorne Street

Ⓓ *Ida McDougall*—1435 Lorne Street

Ⓔ *George Appleby*—1300 block of Cornwall Street

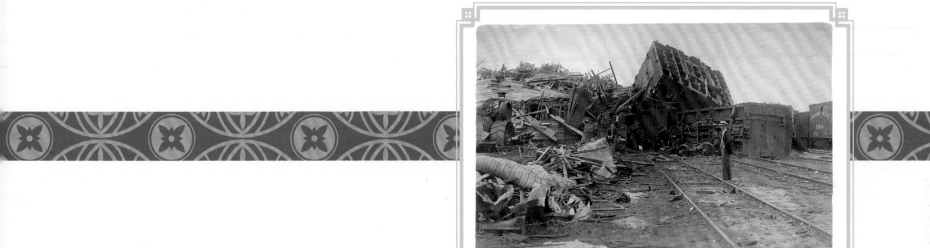

After passing Regina's business district, the tornado then struck the railway yards along the Canadian Pacific Railway (CPR) tracks, the warehouses along Dewdney Avenue, and finally the residential area to the north. By this time, the area hit by the storm was slightly wider than earlier, so structures on Scarth and Hamilton streets sustained damage like those on Smith, Lorne, and Cornwall.

The area between South Railway and Dewdney avenues contained the CPR round-house, grain elevators, and several sets of tracks filled with boxcars, all of which suffered extensive damage. The *Leader* provided a summary of the situation in the CPR yards:

The C.P.R. is wiped out, all except the station. Cars are twisted and warped together as if some giant had taken them in his hands and tied 'em. Stock, cattle, pigs, chickens are strewed about; elevators are spread over the yards, wires are down beyond immediate repair, and a scene of desolation beyond words is there.[1]

One of the biggest problems in the track area was caused by the collapse of the large Winnipeg Elevator Company's grain elevator across four sets of tracks and several boxcars which had been sitting on them. The elevator had been filled with grain which increased the damage caused by its collapse because of the weight involved and also complicated removal of the debris by spilling more grain whenever wreckage was removed.[2]

The railway also had several warehouses and receiving sheds in this area which collapsed, leaving their contents either scattered or damaged. One warehouse contained both bags and barrels of sugar, which the *Leader* described now being of "little value" because of "the heavy rain pouring down on the bags," which has left them with "the hardness of cement."[3]

The largest building in the rail yards was the CPR roundhouse, part of which had been completed for only a week. The structure was almost completely demolished and the *Leader* mentioned that all its wooden walls were gone, with the south one being struck by lightning. Three timbers from this building at least 12 feet

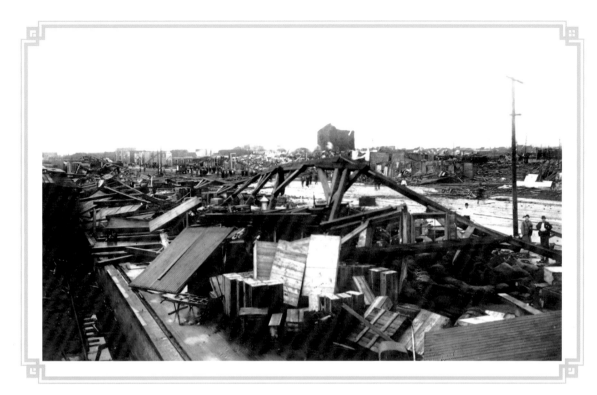

BELOW: This E. C. Rossie photograph shows the wreckage of the CPR freight sheds in the foreground and some of the damaged warehouses across Dewdney Avenue, with a damaged freight car lying many metres away from the tracks (right of centre). Also in the background are ruined houses in north Regina.

ABOVE: Freight sheds were destroyed, and their contents scattered along the tracks or elsewhere.

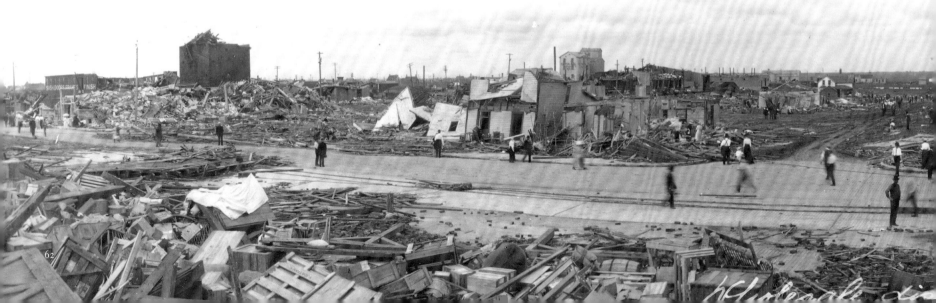

in length were carried north by the wind and driven into the ground so hard that only half of them was visible. Surprisingly, the turntables escaped damage and were used by the railway to help clear all the wreckage.[4]

The rolling stock of the railway was also scattered widely. As the *Leader* reported, "a huge snow plow which had been standing on one of the side tracks several hundred feet from the round house was carried by the tornado and deposited in the pit of the turn table."[5] Four cabooses were piled in a heap, and a bunk car containing two men was thrown 50 feet, travelling through the brick wall at the east end of the round house, somehow without seriously injuring the men. However George Craven, a dairy instructor from New Zealand, was not so lucky. His body was found near the roundhouse where he had been crushed by a boxcar.

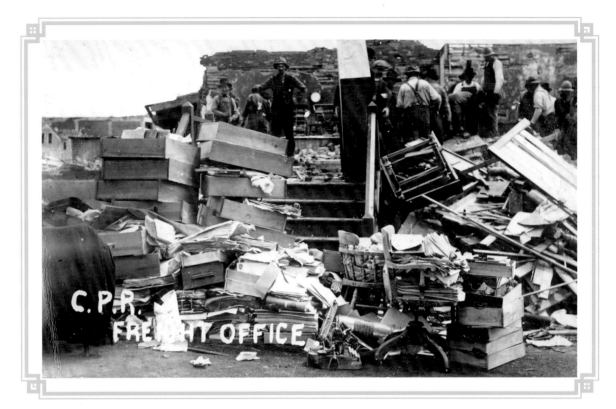

ABOVE: Even the freight office was destroyed and the records in it left exposed to the elements.

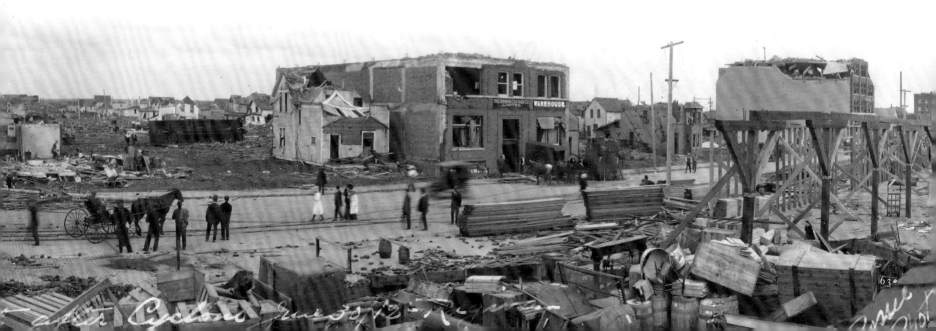

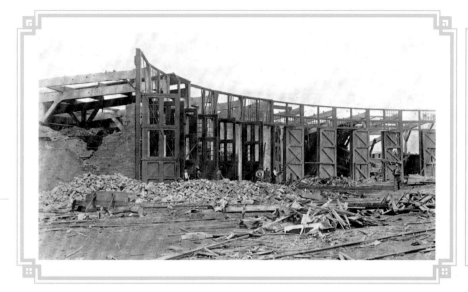

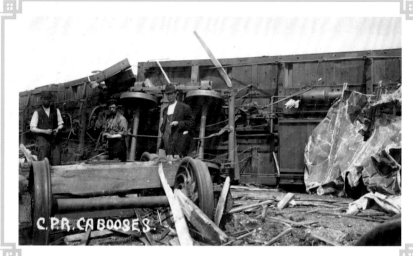

The CPR suffered damage to almost all its buildings except the main station. Even the brick walls of the roundhouse, pictured here, blew down. G. B. Craven's body was found in this area.

Some rail cars, such as this caboose, were overturned.

Many of the boxcars in the CPR yards were filled with goods, livestock, and even people. The *Leader* reported the experiences of two individuals:

Two of the men injured were strangers to Regina, traveling in charge of a car of cattle. When the tornado swept down on the yards the cars were thrown off the track and men and cattle tossed about together. One of the men was struck by flying boards and severely cut about the head and face. His companion was thrown about so violently that he remained unconscious for some time and on regaining consciousness was unable to recollect a single happening of the day. Where he had been, what happened to him were things of which he knew absolutely nothing.[6]

The *Standard* reported a similar story:

W. R. W. Parsons' groom was unloading horses from the box car in which they had been shipped from Calgary, when the storm broke. The groom had just taken the last horse out of the car when he saw the cloud about to break. The horse was hurriedly replaced in the car and the door closed. The wind carried the car over and over, and horse and man turned with it. Neither was injured.[7]

"All Warehouses Gone"[8] was the headline the *Leader* used to describe the damage done on Dewdney Avenue between Hamilton Street west to McIntyre, immediately to the north of the CPR tracks:

What had been an imposing array of fine warehouses and modern brick structures is now a mass of ruins. The Monarch Lumber company's warehouse and yard was badly wrecked. Just at the rear of this on Hamilton street the Rogers Lumber company's sheds are largely destroyed and nothing but the concrete foundation remains. The street is strewn with the roofs of houses and buildings. Wires and poles make a network of the street and render it most impassable.

Continuing on Dewdney street, the lofty Ackerman Block, only erected last year, was sadly injured. The roof was torn completely off and the top story walls thrown from their height to the ground many feet away. The rear of the building was also carried away.

The Regina Cartage Company's warehouse, a smaller building, was also partially destroyed. The Laird Building in which was housed the Western School Supply Company and the Canadian Consolidated Rubber Company, was destroyed almost completely with the main entrance on Dewdney street standing with its conspicuous brass sign plates disclosing the names of the former occupants of the building.

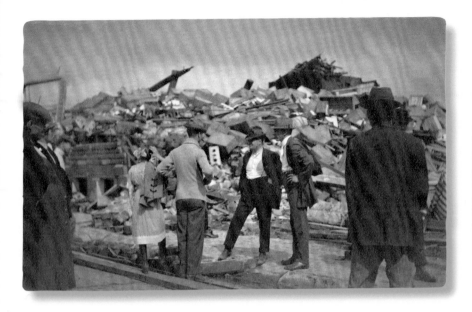

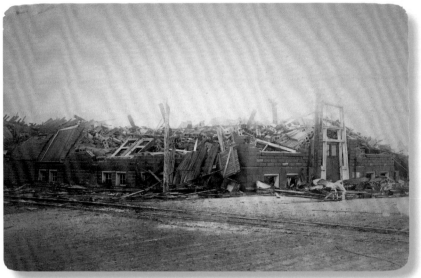

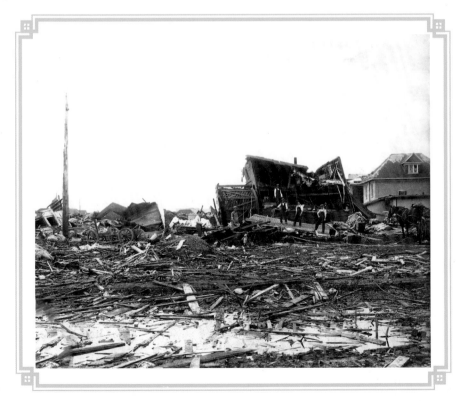

The Rumely Company's warehouse, a galvanized iron structure was laid flat on the ground, but the heavy implements stand out among the ruins. C. S. Hyman's plant also suffered the devastating force of the tornado. A boxcar from one of the spur tracks carried by the terrific force of the wind is lodged on top of the ruins. The Cushing Bro's warehouse and planning factory, a wooden group of buildings, are leveled to the ground and a trace of the large buildings can be seen. An elevator near the Cushing company's building is also sadly mangled and will not be rebuilt.[9]

Individuals in these buildings were forced to take refuge from the storm. Four men in the Laird Building had to seek safety twice, according to the *Leader*:

When the storm came up, they left the front of the building for the rear which they considered safer.

TOP RIGHT AND LEFT: Laird's Warehouse, a substantial three storey, cement-brick structure on Dewdney Avenue was reduced to rubble. The man with his hand on his hips is E. N. Ruggles, the bookkeeper at this company. The owner, H. W. Laird, also had his home damaged, as the picture on page 44 shows.

BOTTOM LEFT: Businesses both small and large were destroyed. This photograph shows the wreckage of a small carpet factory.

The walls fell with a crash, and the roof came in pinning the four beneath it. Another gust followed instantly, and the roof was lifted sufficiently to release its prisoners.

They took refuge in an empty box car standing outside. The second car from theirs was torn loose from the string, picked up and carried across the street by the wind, falling in a wrecked mass on the further side. Their own escaped.[10]

The district north of the CPR tracks and Dewdney Avenue was home for many of Regina's working-class families. Houses in this area were smaller than those on the south side of the city, built closer together, and often lacking indoor plumbing facilities. They were built of wood rather than the stone or brick used by the more affluent, and therefore more vulnerable to the vicious winds of the tornado. Photographs reflect this vulnerability by showing entire blocks with almost no buildings left standing. Another difference between this district and that situated south of the tracks was the high density of population. As an example,

the *Standard* listed 96 people as living in nine buildings on the east side of the 1400 block of Cornwall Street, with only one of those being described as a rooming house with 30 residents.[11]

Although the newspapers contain fewer stories about the citizens of this area than those living south of Victoria Park, some of their experiences were recorded, such as the *Province*'s description of one group's survival:

The Machett family, who lives on the north side, had narrow escapes when their house was

blown down around their ears. Two daughters and their mother and two boarders, employees at the C.P.R. were in the house at the time the cyclone hit it. The men jumped from the second storey window as the walls started to cave in, and escaped unhurt. The first intimation that the girls had of the seriousness of their predicament was when the sewing machine came hurling across the room where they were, on the second storey, and narrowly missed them, then the bureau was swept from its position, and the next thing they knew they were climbing out over the ruins uninjured. The only one in the house to be injured was Mrs. Matchett, and she only slightly.[12]*

> "THE WALLS FELL WITH A CRASH, AND THE ROOF CAME IN PINNING THE FOUR BENEATH IT. ANOTHER GUST FOLLOWED INSTANTLY, AND THE ROOF WAS LIFTED SUFFICIENTLY TO RELEASE ITS PRISONERS"

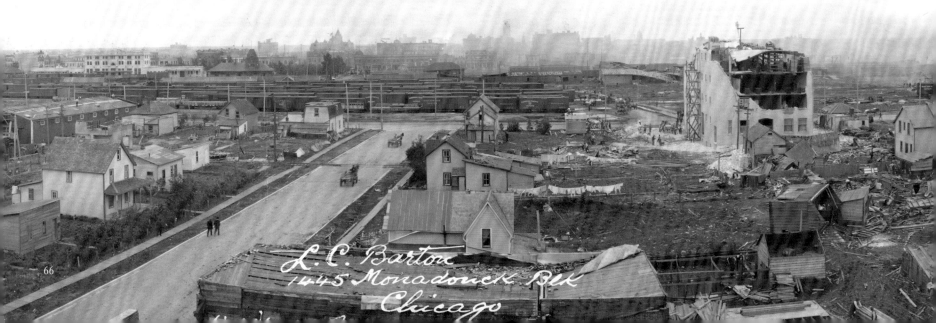

L. C. Barton
1445 Monadnock Blk
Chicago

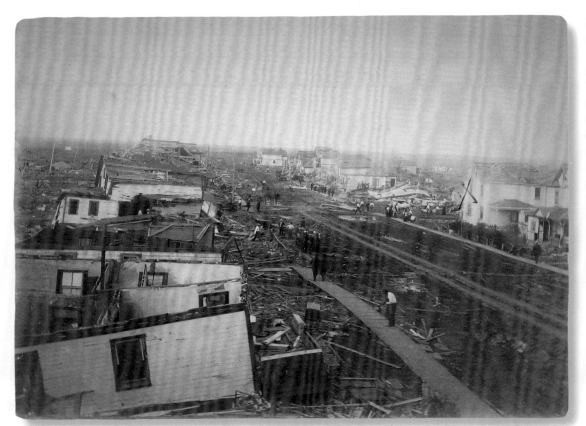

RIGHT: Cornwall Street north of the CPR tracks suffered extensive damage.

BELOW AND BOTTOM OF FOLLOWING TWO PAGES: This panoramic view of Regina's north side between Scarth and Cornwall streets looking south towards the CPR tracks and the downtown area beyond shows the extensive damage to residences in the area as well as the substantial Ackerman Building on Dewdney Avenue (facing page). Homes on Cornwall Street were completely flattened, such as the one in the foreground on the bottom of page 68 where members of the McDougall family were either killed or injured. In the extreme right of the photograph (page 69) may be seen the tents erected on Dominion Park, which housed both off-duty patrolling officers and people whose homes had been destroyed.

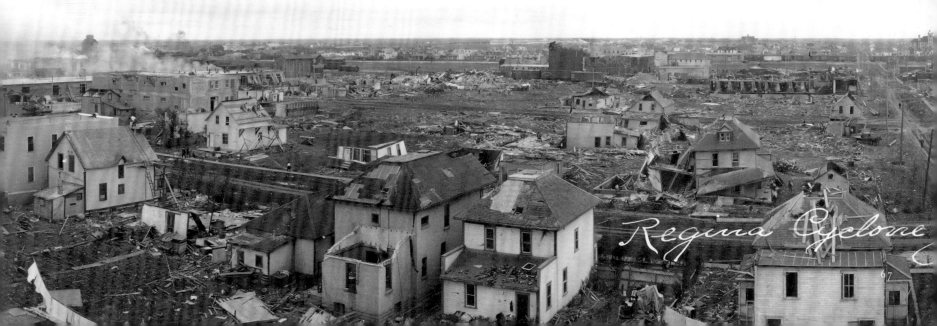

Regina Cyclone

The *Leader* told of another family that also managed to escape unharmed in spite of the total destruction of their home:

While many sad and harrowing tales are told, more are of miraculous escapes. Mr. and Mrs. Aird and their family, of 1275 North Cornwall, were upstairs when the storm came, and when their upstairs windows crashed in they rushed for the stairs and went down in a mass.

When they reached the bottom the front door was torn from its hinges and they, still clinging together, were hurled out and whipped away several rods and escaped uninjured. One instant after they were swept out the house was crushed to match-wood.[13]

> "...STILL CLINGING TOGETHER, [THEY] WERE HURLED OUT AND ... ESCAPED UNINJURED. ONE INSTANT AFTER THEY WERE SWEPT OUT, THE HOUSE WAS CRUSHED TO MATCH-WOOD."

Many north end residents were not lucky enough to escape serious injury. One such individual was Mrs. N. Saunders, a widow who had recently come to Regina after burying her husband in Ontario. A doctor reported that he found her and one son in the home of a friend after her house on Scarth Street north was completely destroyed. Her two other children had been taken to hospital, and she did not know if they were still alive or not. She was very badly bruised and cut as was her son, but both of them were heroic as they were treated. The doctor described her "marvelous calmness, courage and, I might say, cheerfulness."[14]

Other north end residents suffered fatal injuries, three of which occurred on the 1400 block of Lorne Street. Mrs. Laura McDonald went out to her back yard to close the family chicken coop securely and was knocked down and killed by flying debris. Her neighbours right across the street, the McDougalls, lost two family members and had others injured.

The *Leader* reported the incredible hardships that the tornado caused for this family:

James McDougall and his little daughter were buried yesterday afternoon. Mrs. McDougall and her other three daughters are in the Grey Nuns Hospital and so serious is her case that they dare not tell her of her husband's death.

They lived in a rented house on north Lorne street and were not in very good shape financially

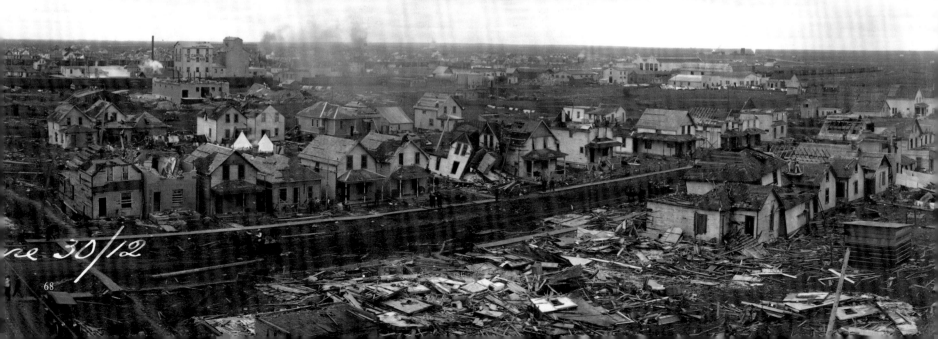

before the coming of the cyclone. It swept away everything they had in the house and fatally injured the breadwinner and the baby, and it may be that the mother may yet succumb to her injuries. Besides the three little girls who are in hospital with their mother there are four boys, none old enough to support the home should the mother recover and who will be scattered should her injuries prove fatal.[15]

This article concluded with a plea from their pastor, Reverend Harton of Rae Street Methodist Church, for help for this family, and was followed up the next day by a report that all of the surviving members of the family were doing better, with some of the children able to play with presumably donated toys and their mother extending gratitude to those who were helping her. The other papers also published requests for help for this family.

Another casualty of the storm was George Appleby, a homesteader from the Swift Current area who had spent two years in Regina during which time he had been very active in the Boy Scout movement. At the time of the storm,

he was in a tent at the rear of a house on Cornwall Street north of the tracks. As he realized the power of the storm, he ran towards the house but just as he reached it, it collapsed and smothered him. His body was found a day later and identified.[16]

In the wake of the storm, very few buildings were standing in Regina's warehouse and northern residential districts. Wreckage was strewn everywhere, particularly across the railway yards, blocking the tracks and thus interfering with cross-Canada railway traffic. Downed telegraph lines left the city cut off from the rest of the country. The storm also took its toll on humans

in this area, with four more people dead, many injured, and many more left homeless and with almost no personal belongings. ❖

ABOVE: In the north end, serious damage occurred further east than in other parts of Regina. William Hamilton's house at 1300 Hamilton Street lost its roof and several outside walls.

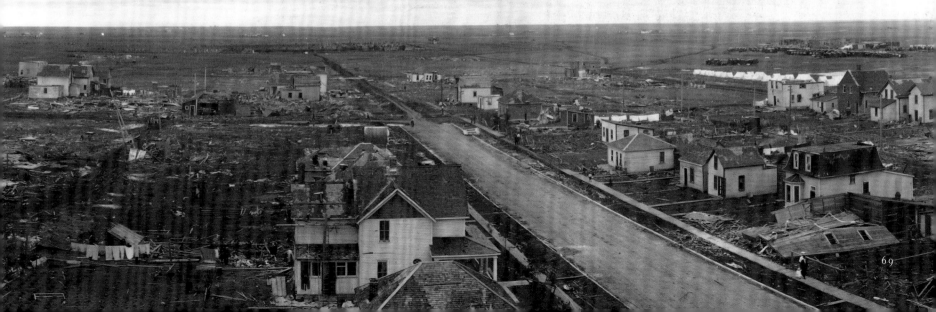

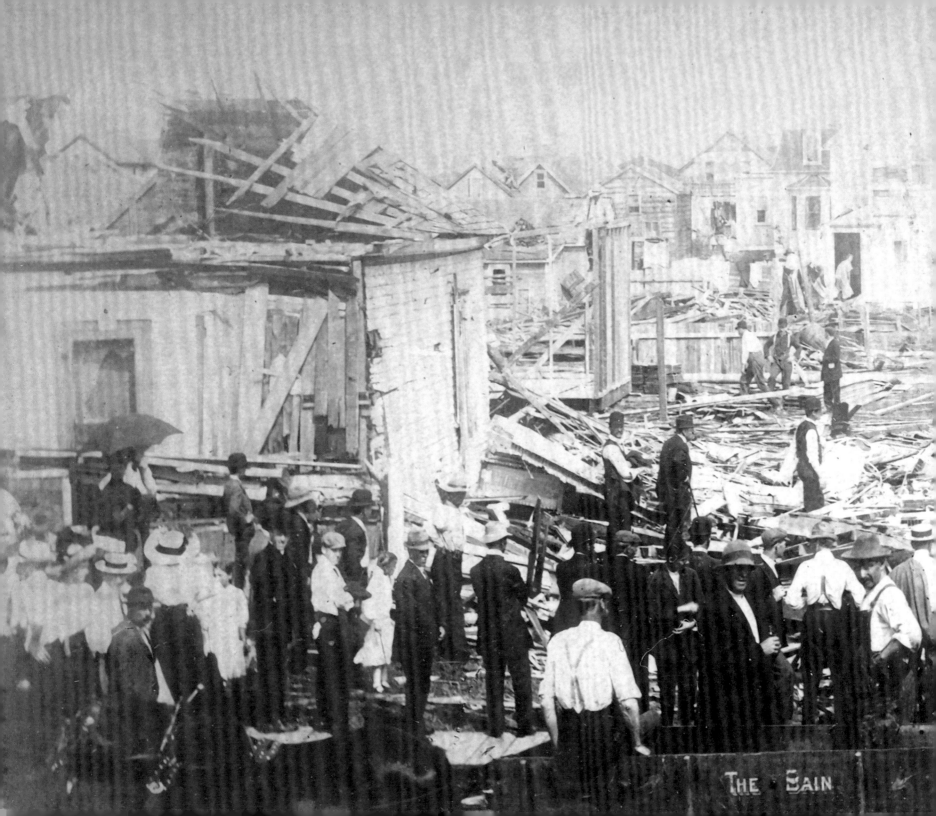

CHAPTER 8

Caring FOR THE Victims

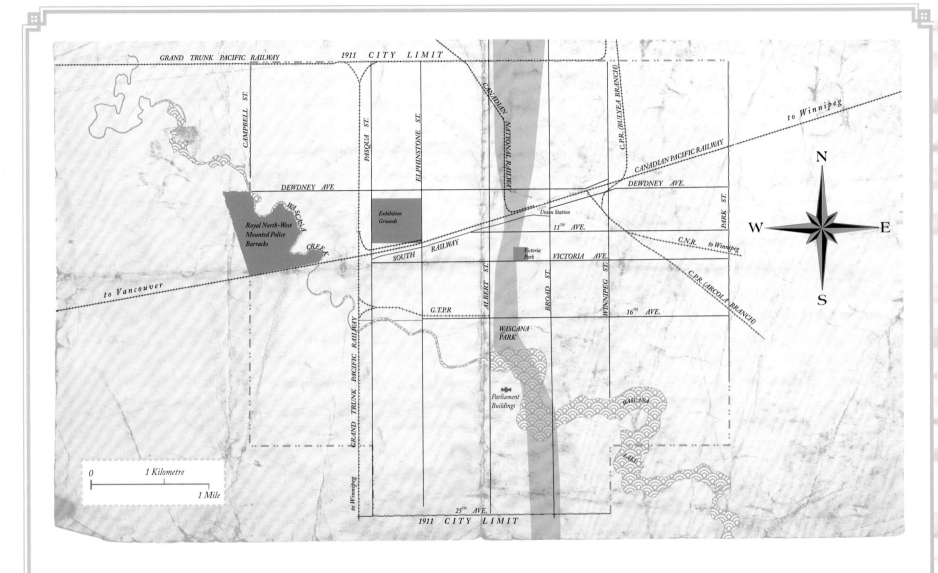

Overview of the Path of the Tornado

■—PATH OF THE TORNADO

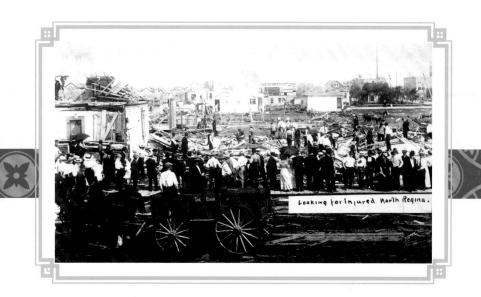

Looking for Injured North Regina.

At 4:55 in the afternoon, the siren on the power house in Regina sounded to warn citizens of danger. This first official response to the tornado came too late, with the storm having passed completely through the city in three minutes, according to one account.[1] The tornado's assault on Regina had already left some of its citizens either injured or dead, the numbers of which were initially unknown and often exaggerated. Thus the city faced the tasks of assessing the extent of the problem and dealing with these casualties.

One of the first problems facing Regina in the aftermath of the storm was the recovery of the injured and dead from all the damaged buildings. Initially, this seems to have been handled spontaneously by citizens who first looked to extricate themselves and their families from the rubble of their homes or businesses and then, if they were able, tried to do the same for their neighbours. Several of these rescues have already been described in this book. These volunteers were soon assisted by the city police force, supplemented by members of the Royal North-West Mounted Police brought in from the training depot located in the city and by special constables sworn in by civic officials.

73

C. B. Delarue, a guest at the Clayton Hotel when the storm struck, described some initial reactions to the disaster. When he saw the approaching tornado, he had left his room and headed for the lower floor of the building and had, as he said in a letter, "drowned his fears" as the "building rocked something terrific" by playing the piano.[2] When the wind lessened, he headed out to survey the damage and help out where he could. He first assisted men moving merchandise out of store windows downtown and then headed across Victoria Park to the residential district on Lorne Street which he had admired the previous day:

> "WHEN I ARRIVED THERE THE SCENE WAS TERRIBLE. PEOPLE WERE RUNNING THIS WAY AND THAT, SCREAMING. STRONG MEN WERE CRYING OUT THAT THEIR WIFE OR CHILD WAS UNDER SUCH AND SUCH A PILE."

When I arrived there the scene was terrible. People were running this way and that, screaming. Strong men were crying out that their wife or child was under such and such a pile.

Other people were dragging the injured out. It made me turn sick. Everybody seemed distracted.

Soon, however, every available vehicle was pressed into service and they made for the hospitals with the injured.[3]

The man responsible for organizing more formal relief efforts was Regina Mayor Peter McAra. He was the owner of a large insurance agency, McAra Brothers and Wallace, and also had extensive experience in civic government. He had been an alderman from 1904 until 1906, serving as chair of the city's finance committee, and had been mayor in 1906 as well, at a time when the city took over the lighting plant. Re-elected in 1911, he had also presided over the opening of the street railway system, so he was very familiar with all aspects of civic administration.[4]

McAra had actually seen the tornado approaching Regina from his own yard on Victoria Avenue near Hamilton Street. Years after the event he recounted his experience to a *Leader-Post* reporter:

Returning from a drive in his Studebaker to show the superintendent of the Grand Trunk Pacific Railway system the beautiful young city, the gentlemen reclined in the garden. Mr. McAra remarked that a storm was brewing. They went indoors. Mr. McAra started to close the windows. The storm broke in cyclonic destruction. It took but a few moments for him to rush to the window on the circular stair, from where he saw the Metropolitan church in ruins. The house was not in the path of the storm.[5]

As "active commander of rescue work"[6] one of McAra's first acts was setting up three committees on July 1. One was a General Executive Committee for Relief, quickly shortened to the Relief Executive, made up of McAra himself, the five aldermen of the council's Finance Committee, the city commissioner, and three private citizens, prominent Regina businessmen. The other two committees, also chosen from the business community, were responsible for relief activities in the south and north of the city respectively. These committees worked fairly closely together to deal with the short-term problems such as identifying the dead, helping the injured, providing food and shelter to those left homeless, and maintaining order. One of their first tasks was "a complete canvass of the city to determine the precise nature and dimension of public and private needs so that they could direct assistance where the requirement was greatest."[7]

Since the preliminary estimates of the number of casualties exceeded the number of bodies found, reconciling these numbers was one of the early challenges. Since the storm wiped out telephone service, people could not find out where their family members or friends were, and sometimes assumed the worst, particularly if they suspected these individuals had been in the storm's path. Thus, people who could do so headed to the hospitals looking for their loved ones. The newspapers tried to assist in this process by publishing names of those reported missing, and frequently followed this up by announcing in

following issues that these people had been located. The *Standard* also "had its reporters make a personal canvass of every heap of ruins and secure from the homeless people estimates of their losses"[8] from which the editors derived a comprehensive list of both injuries and property losses which was published July 2.

There were two places in the city where authorities expected to find more bodies, so plans were made to search these. One was Metropolitan Methodist Church, on Lorne Street and Victoria Avenue, which lay in ruins. E. St. James, who had taken refuge from the storm under the church's portico, told a former *Province* reporter that he had seen 10 or 12 people go further into the church and had not seen them come out. This led to a search of the ruins, headed by the mayor, reported in the *Leader*:

In the earlier part of the evening several men were working at the west end of the building but later on all the men were concentrated at the east end and in the portico. At least seventy-five men worked energetically, hauling out brick after brick and stone after stone, but as the evening wore on and no disfigured corpse was found some of the men were ordered to leave the work as it [was] possible to accomplish the same amount of work with less men because of the limited space. His Worship Mayor McAra and [Fire] Chief White ably directed the work and with their willing helpers the pile of debris grew less and less until the floor in the fore part of the vestibule

Rescuers searched both the front (TOP) and the back (BOTTOM) of Metropolitan Church looking for victims, but neither injured nor dead were found.

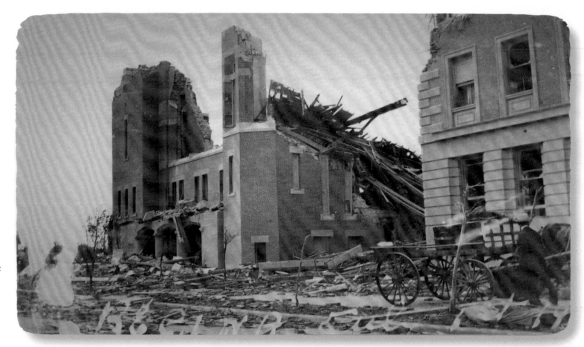

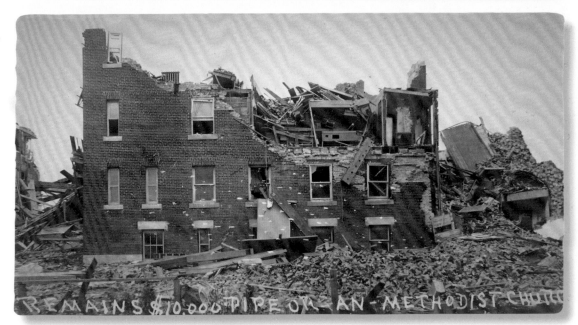

REFER TO FILE 60

CITY CLERK'S OFFICE.

FLOREAT REGINA

July 9th, '12.

Regina, Sask.

J. E. Appleby Esq., M.E.,
 95 Springhurst Ave.,
 Toronto.

Dear Sir:

In reply to yours of the 5th inst. which his Worship, the Mayor, has handed to me for reply, I very greatly regret to have to inform you that the Scout Master Appleby you mention was killed in the recent disaster, and his funeral took place yesterday. The Sons of England arranging for same. The Boy Scouts also attended, and a large number of the public followed as Mr. Appleby was well known, and respected locally. I am instructed, by his Worship, the Mayor, to express, the deepest sympathy of the Citizens of Regina, generally, with all relatives of the deceased. His death so far as is known was instantaneous, he being pinned under a huge pile of debris. Again extending my sympathy and that of the Citizens, generally, I am,

Yours Truly
A. W. Pool.

City Clerk.

AWP/SS

City Clerk A. W. Pool had the unfortunate duty of informing George Appleby's relatives of his death. Appleby was the last victim in what has remained the most destructive tornado in Canadian history.

was exposed to view and still there was no trace of anyone.

After several hours of the hardest kind of work the debris had all been practically cleared away and the works were called off as it seemed certain that there were no victims to be found.

The crowd which had been waiting anxiously the entire evening saw the ambulance drive away empty and gradually melted away.[9]

The other rumoured site of many bodies was Wascana Lake. Several people who had been swimming or boating at the time of the storm reported seeing boats on the lake or flying across the park as the wind hit the area. There were reports that a party of itinerant performers, the Albini-Avolos theatre company, had been boating at the time and had not been heard from. Alex Rowbotham could not locate the friends swimming with him and assumed they must have drowned. The issue was complicated because the boat club and Hemans boat rentals could not count their vessels since they were smashed and scattered all over Wascana Park and beyond.

All of this led to speculation about the need to search the lake for bodies. One suggestion was to drain the lake, although this was vetoed by the city's medical health officer because "it might start a typhoid epidemic."[10] Another suggestion was using dynamite on the lake to disturb the bottom and thus allow any bodies to rise to the surface. However, by July 4, this discussion ended because all missing boats and individuals had been accounted for.[11] The largest missing group, the theatre party, had in fact been picnicking several miles east of the city and did not return until the storm was past. One member of this party, at the time just beginning his acting career, was young William Henry Pratt, who was later to gain fame using the stage name Boris Karloff.

The clergy and the two funeral homes in Regina found themselves extremely busy dealing with the funerals of the storm's victims. On July 2 the *Leader* reported that all the bodies recovered had been embalmed so that the relatives of the deceased could make whatever plans they wanted for burial, either in Regina or elsewhere. For the next few days, all three papers carried announcements of funeral arrangements and descriptions of the services, some held in private homes, some in funeral parlours, and some in the churches. Several were conducted by Rev. Murdoch MacKinnon whose own home lay in ruins.

Some of the circumstances surrounding two funerals were unusually stressful. John Scott of Winnipeg rushed to Regina to bury his brother

James who had been listed as one of the casualties; however, on his arrival he found his brother calmly smoking a cigar. The man killed had been another person with the same name. According to the report in the *Province*, "The rush of joy was almost too much for Mr. Scott and he partially collapsed and it was some moments before he regained control of his feelings, when the real re-union took place."[12] This prompted the newspaper to print the following highlighted notice:

The confusion existing regarding the death of James Scott, of the Customs Department, is causing a lot of anxiety and worry to the friends of James Douglas Scott, president of the North-west Canada Lands C. Jas. D. Scott, the real estate man, is unharmed.[13]

A more unpleasant shock occurred to the sister of Bertha Blenkhorn. This woman, identified only as Mrs. Smith, arrived in Regina from England for a visit on the morning of July 4, knowing nothing about the tornado which had killed her sister and brother-in-law. She was just in time to attend their funerals that afternoon.[14]

The most extensively reported and elaborate funeral was that of George Appleby. It was attended by both troops of Boy Scouts and members of the Sons of England Benefit Society, of which the deceased had been an officer. After the formal funeral service in St. Paul's Church with the bell tolling, the funeral procession proceeded to the cemetery in the north end of the city, traveling past the ruins of the "crumpled mass which represented his home which fell on him as he ran from his tent to its shelter."[15]

In the cemetery, a Boy Scout trumpeter played "The Last Post" at the end of the burial service, then members of the Sons of England "took up the task of filling in the grave," and finally the crowd of over 200 spontaneously began singing "Nearer, My God, to Thee."[16] In other cases, the funeral announcements noted that the deceased were being taken out of the city for services in their original homes.

The treatment of those injured in the tornado put a severe strain on Regina's medical facilities and personnel. In 1912, the city had two hospitals, both in the same location they currently occupy. The first unit of the Regina General Hospital had been built in 1909, and the Grey Nuns Hospital, now the Pasqua, had opened its doors on Dewdney Avenue in 1911. In the tornado's aftermath, these facilities

The most seriously injured victims of the tornado were treated at the newly completed Regina General Hospital, but there was not enough room for everyone who needed care.

were overwhelmed with injured people, so the city established additional treatment centres around the city, with locations being announced in the *Leader* on July 1: St. Paul's Parish Hall, Immigration Hall, Williams Block on Rose Street, the new CNR Freight Shed, and Moore Light Building.

People also looked for help in other locations, such as Fire Hall Number 2 in the north end on the corner of Scarth Street and 8th Avenue, which at one time housed 75 injured people, two of whom died, according to the *Standard*.[17] The *Leader* described the chaotic scene which existed there:

The Fire Hall in the north end of the city was filled with the injured and dying. Upstairs, and on the ground floor dozens of injured lay on mattresses which had been brought in. Men, women and little children mingled together. One man with white lips and ghastly eyes lay feebly breathing and in a few short minutes his heart had ceased to beat. One man lay with bleeding head gasping for breath and at his side his son who had crawled from the wreckage of a building up town which had fallen about his head, and was doing all in his power to save his stricken father. Yeen Gun, a Celestial with broken limbs, lay surrounded by sorrowing fellow countrymen. Some men even in their agony, begged the ministering women to go and help those more seriously injured. For over an hour no physicians could be found and the injured and dying were without attendance save for the crude attempts of the men in the building.

Fully fifty injured were sheltered in the fire hall and one by one they were taken in ambulances and impressed to the overflowing hospitals.[18]

The city's doctors and nurses rushed to the hospitals or other treatment centres to deal with the influx of wounded. Their ranks were swelled by the arrival of others from other cities. A trainload of medical personnel and supplies arrived in Regina from Moose Jaw the night of the storm, and others came from Winnipeg the following morning. The city set up a medical headquarters headed by Dr. John Black, who was responsible for overseeing all medical matters. Within a day of the storm, Black had the newspapers printing an appeal for injured people being treated in private homes to notify his office so he could compile an accurate list of injured and supply additional assistance if it was needed.

Understandably, the hospitals had problems coping with the sudden influx of patients, many in very serious condition. Montagu Clements described the experience of his friend who had been rescued from a collapsed house on Smith Street and taken by ambulance to hospital:

The hospital was a busy scene of confusion. Frantic relatives and friends were trying to identify victims on stretchers and asking questions in anxious and tearful tones. My friend was carried into the superintendent's office where he was put down on the floor, as there was no convenient place for an examination until a dead body had been removed from a cot. The doctor could find no fracture, or internal injury, but told him to lie still. Later he was helped off the bed and even tried to assist the doctor by holding a lamp while a scalp wound on another victim was examined. His hold was too unsteady, however, and the doctor signaled to a nurse to take the lamp.[19]

Conditions at the hospitals remained difficult for a few days, as the *Province* reported on July 2:

The scene at the General Hospital is heart-rending. The hospital is crowded with patients from basement to garret, every available foot of space has been at one time or another occupied. Cots are lined along the hall and every ward is filled.

"We have not turned away a single patient," said Dr. Deakin, medical superintendent of the hospital. The doctor has been on duty practically without any rest for twenty-four hours. Other city doctors have worked as long and as heroically. Nurses and doctors are here from Moose Jaw and other outside points. These who are not busily engaged with the patients are preparing bandages and dressings for the injured. The nurses like the doctors have been steadily on duty since the cyclone struck Regina and are wearily but cheerfully still performing the duties of mercy. The hospital is being visited by hundreds of anxious relatives and many a pathetic and touching scene has transpired.

The injuries range from slight concussions to broken backs and broken limbs and terribly crushed bodies. The moanings of the suffering and dying are heartbreaking and the most touching appeals are made by the wounded who piteously inquire

"THE SCENE AT THE GENERAL HOSPITAL IS HEART-RENDING. THE HOSPITAL IS CROWDED WITH PATIENTS FROM BASEMENT TO GARRET, EVERY AVAILABLE FOOT OF SPACE HAS BEEN AT ONE TIME OR ANOTHER OCCUPIED."

about parents, separated from their children, wives from their husbands, ignorant of their fate. Every effort is being made to secure the information, but in the current state of chaos this is impossible.[20]

The article noted that conditions were much the same at the smaller Grey Nuns Hospital.

The emergency centres also provided treatment for injured people who walked or were carried to them. As time went on, doctors and nurses were assigned to help care for patients there. At least one nurse made a surprising discovery when she was helping a patient into bed at St. Paul's Hall. The woman was a fortune teller who had been camped on Dewdney Avenue when the storm hit, and had obviously been successful in her profession as the nurse found $300 hidden in her stocking. Mayor Peter McAra received a telegram from her family asking for information about both the woman and her nest egg.[21]

One week after the storm, conditions in the medical facilities were much better, according to the *Province*:

The number of injured now in the city hospitals total 78. Of these, 53 are in the General, 12 in the Grey Nuns, and 13 in St. Paul's Parish Hall. The patients who have been in St. Andrew's Hall were all moved to the General Hospital yesterday afternoon. Inquires at the different hospitals last evening brought the same reply on each occasion. "All our patients are doing remarkably well, and none is in any immediate danger."[22]

In all, Regina had to cope with 28 fatalities and an estimated 200 seriously injured people requiring treatment in the aftermath

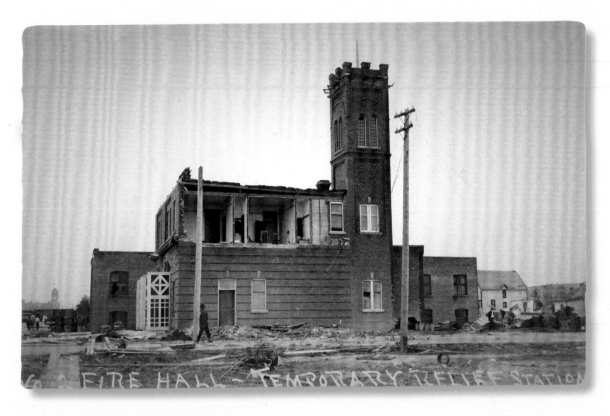

of the tornado. These demands were met by a combination of volunteers and professionals, sometimes augmented by help from outside the city. According to Mayor McAra, the response to the disaster was so good that representatives of the St. John's Ambulance Association who arrived in the city a few days after the tornado "said that there was nothing they could offer to do to improve the situation" except make a contribution to the relief fund.[23] The newspapers also offered praise to those giving care and assistance to the tornado's victims. ❖

Tornado victims north of the CPR tracks in Regina headed to No. 2 Fire Hall at Scarth Street and 8th Avenue seeking safety and medical aid, in spite of the fact that this building had sustained damage.

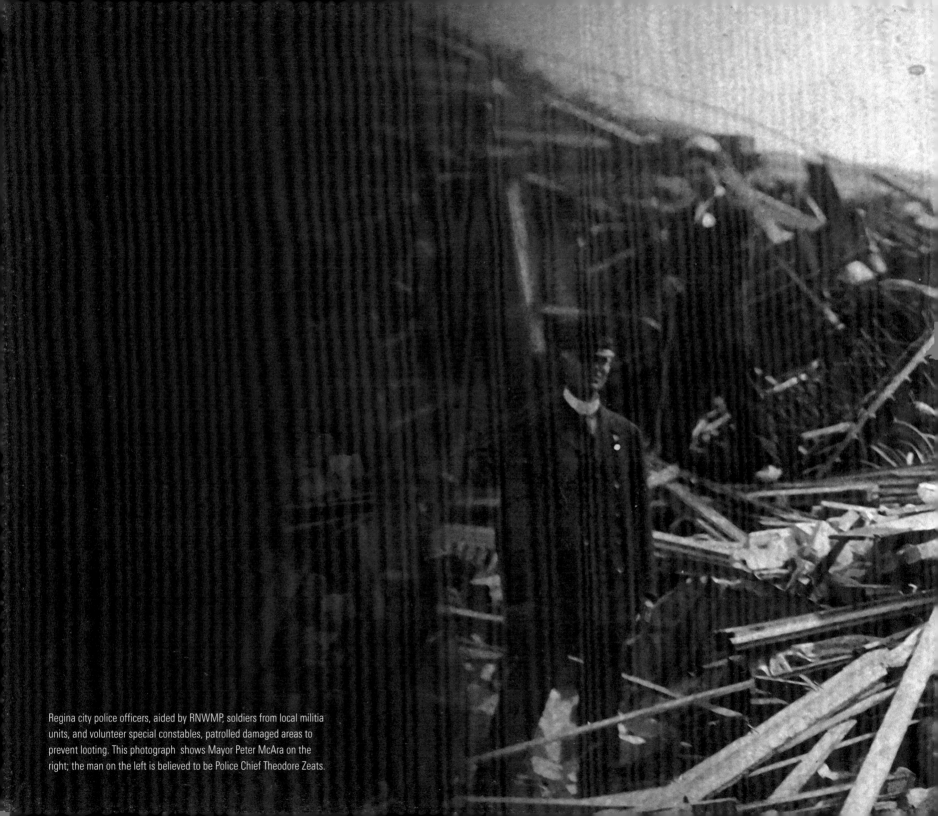

Regina city police officers, aided by RNWMP, soldiers from local militia units, and volunteer special constables, patrolled damaged areas to prevent looting. This photograph shows Mayor Peter McAra on the right; the man on the left is believed to be Police Chief Theodore Zeats.

CHAPTER 9

Providing Essential Services

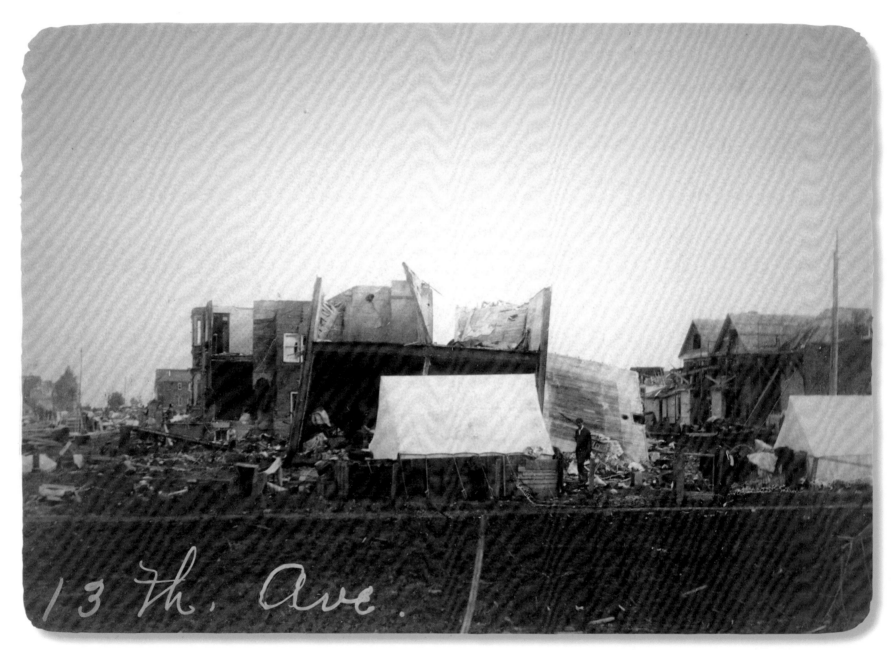

13 th. Ave.

Civic officials provided tents to residents as temporary residences or storage areas.

In the aftermath of the tornado, Regina Mayor Peter McAra was faced with the task of setting priorities to provide emergency services and restore the normal functioning of the city. Two of his earliest decisions were announced in the *Leader* on July 1:

> *Proclamation—In view of the terrible happenings of today I deem it my duty to declare all Dominion celebrations indefinitely postponed. I also request that all bars of the city hotels remain closed for the day.*[1]

Like most Canadian cities in the early 20th century, Regina had no existing plans, or funds, for what we now call disaster recovery. Thus, when the tornado hit the city, the civic government and affected organizations and individuals had to find ways to react to the emergency on an ad hoc basis. The first priority was to help residents who were left without shelter or places to prepare meals. A second priority was to ensure the safety of individuals and the protection of private property in the devastated areas. Finally, the tornado had disrupted basic communication and transportation services and left the city temporarily without power, all of which had to be restored as soon as possible.

The tornado had left some 2,500 people needing shelter. Much of this was provided by friends or relatives in undamaged parts of the city, although these informal arrangements complicated the task of civic authorities trying to assess the number of casualties. People who could afford it and were able to find vacancies took rooms in local hotels, although some of those at the edge of the storm area

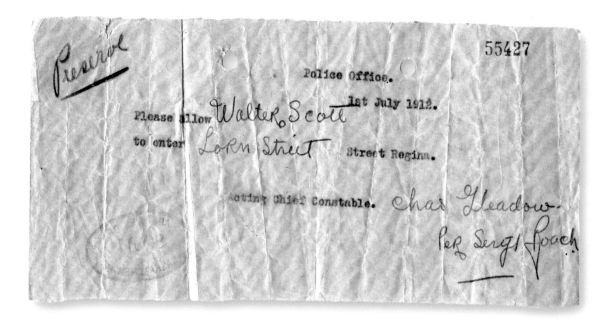

55427

Police Office.

1st July 1912.

Please allow Walter Scott
to enter Lorn Street Street Regina.

Acting Chief Constable. Chas Meadow.

Per Sergt Roach

had numerous broken windows. The Relief Executive established on July 1 began making arrangements for those needing help by acquiring tents which could be set up either in public parks or on individuals' property if there was space available. Both Dominion and Broad Street parks soon contained tent cities. Civic authorities also provided cots at shelters and schools in various areas of the city and advertised for citizens to make room in their homes for those needing shelter.

People whose homes had been damaged also could not provide meals for themselves and their families. The *Province* reported that this emergency was being met in two different ways:

Up to the present comparatively few are availing themselves of the food being provided at the city hall and St. Paul's parish hall on the south side and St. Andrew's on the north side.

Packed all day by those outcasts who are not destitute of funds, by large numbers of visitors to the city and by clients of restaurants which were wrecked by the cyclone, the restaurants which remain undamaged had considerable difficulty in catering to the enormous crowds which thronged them from five o'clock in the morning until a late hour at night. So much had the demands taxed their resources that in many of the restaurants there was not much choice of dishes even early in the evening.[2]

With their homes completely destroyed, many people were left with nothing but the clothes on their backs, which in one case at least were completely inadequate, as the *Leader* reported:

One woman, the mother of seven children, who has lost all her worldly possessions, was making

merry yesterday over the Edenesque manner in which she and her little ones made their escape.

She had bathed the baby and the three little ones and, because the day was so hot, decided to leave them awhile before dressing them.

She had just finished taking a bath herself when the storm broke with all its fury. Quickly she got into a skirt and next grabbed a coat of her husband's. The baby she wrapped in a corner of the coat. An apron and another coat wrapped the three other tots when in procession the mother and her seven made their way to City Hall. Her great happiness is that they are all alive and uninjured in spite of a very narrow escape.[3]

Although most victims had more to wear than this family, many needed clothes immediately. The newspapers published several appeals for donations, asking particularly for underclothing and footwear, and set up a collection centre in the auditorium of City Hall. Also, volunteer seamstresses were recruited to make alterations or garments.

Civic authorities were very nervous about the threat of looting in the damaged areas and took immediate steps to prevent it. In addition to the city police force of two sergeants and 19 constables, members of the Royal North-West Mounted Police from the training academy, and 150 special constables, most of whom were businessmen, were assigned to rescue and guard duty.[4] Three local militia units which were away on summer training at Camp Sewell in

Manitoba were immediately rushed back to the city to participate in these activities. Individuals who wanted access to damaged areas had to get passes from the chief of police, and the patrolling officers refused access to those without them. Even Premier Walter Scott was issued a pass so he could have access to his own house on Lorne Street. This system worked well, and very few cases of looting were reported. The *Standard* reported on July 5 that two men had been caught taking coats from the rubble, one of whom had done so when it began to rain when he was working clearing rubble, and both had received jail sentences.[5] In another incident, three militia soldiers helped themselves to one bottle of beer each, for which they were initially sentenced to 12 months jail time, but these sentences were later reduced.[6]

By downing telegraph and telephone lines as well as destroying Regina's central switchboard, the storm left citizens unable to communicate with each other and with those in other centres. This situation was rectified when CPR workers were able to restring the lines within an hour so that the rest of the world could hear the message: "Cyclone hit Regina 16.50h. City in Ruins."[7] For the next few days, the 20 telegraph operators worked almost non-stop, with the chief operator having no sleep at all for two days. He estimated that he and his staff had tapped out some 25,000 words, sent by Regina citizens to

assure their families and friends that, in most cases, they were safe.[8]

The damage to the telephone system was greater and thus took longer to repair, although not the weeks or even months originally estimated. Long-distance service resumed within 24 hours, first west to Moose Jaw and within a day to the east as well, from several telephone booths located near the phone company's temporary quarters in the Canadian Northern Railway's undamaged freight office. This company also brought in a temporary switchboard from Montreal. However, it was not until August 11 that local service was restored.[9]

To make up for the lack of telephone service, the Boy Scouts saw an opportunity to provide service, as traveling salesman J. W. Beckman told a *Province* reporter:

With their leader, Captain Appleby, lying dead in a tent, and without direction, the scouts organized as if by magic and rendered the most valuable service of any single organization. With the town in darkness, the telephone system and all means of communication destroyed, the scouts quickly scattered throughout the ruined district and established a system of communication which proved effective and brought prompt rescue to many victims pinned beneath wreckage.

Without rest or food the lads worked for hours. They were pallid and solemn faced as they discussed the death of Captain Appleby.[10]

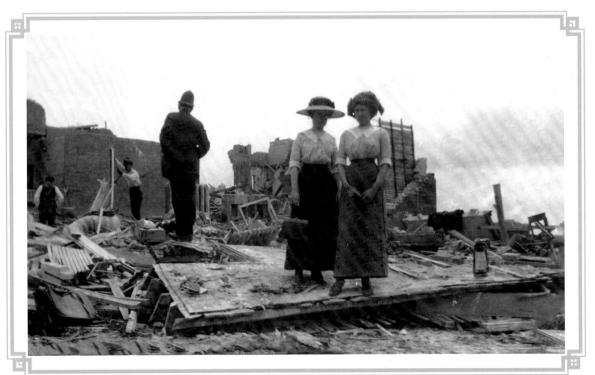

Two women pose for a photograph while a policeman oversees workers sifting through rubble

Although the post office headquarters was east of the path of the storm and thus not damaged, mail service in Regina also experienced problems. Unless storm victims notified postal officials of their temporary addresses, their letters could not be delivered so they piled up in the post office. There was also a huge volume of outgoing mail as citizens sent letters to friends and family living elsewhere to report details of the storm. Much of this mail consisted of postcards with pictures of damaged buildings. The postmaster claimed that the volume of mail both coming and going was greater than the Christmas rush.[11]

Electric power was another service unavailable to citizens in the aftermath of the tornado. The storm took down power lines, and these live wires provided the threat of fire. Mayor McAra reported that his first response to the disaster was to go to the power house and order electric power cut off because of this danger,[12]

> "WITH THE TOWN IN DARKNESS ... AND ALL MEANS OF COMMUNICATION DESTROYED, THE SCOUTS ... ESTABLISHED A SYSTEM OF COMMUNICATION WHICH PROVED EFFECTIVE AND BROUGHT PROMPT RESCUE TO MANY VICTIMS PINNED BENEATH WRECKAGE."

a wise decision which no doubt prevented fires. Then, electricians began the process of locating and repairing the damaged wires so that power could be restored to some parts of the city by 9:00 that evening. The work continued in the next few days as well with over 60 workers, some provided by private businesses such as Whiteford Bros. and others sent from Moose Jaw, installing two car loads of poles and new street lights, which had been ordered before the storm to extend services but were now pressed into service to replace damaged ones. By July 3, all parts of the city except the storm-ravaged areas had power again.[13]

The new street railway system of which Regina was so proud was also shut down by the storm. As the *Province* reported, "the cyclone of Sunday last blew down poles, and put practically all of the overhead work out of place, which made it necessary to do considerable repairs before the cars were again operated."[14] City authorities decided that power was more important than the street

railway, so all available workers restrung power lines first but were able to switch to the street railway overhead lines by July 3. Superintendent Egan promised some service by that evening and expected that the system would be in "ship-shape condition" by the following morning.[15]

The tornado left nearly 10 percent of Regina's citizens without the basic necessity of shelter and also limited their access to food and clothing. Most dealt with this problem in the short term by getting help from people they knew, as a headline in the *Leader* proclaimed: "Census of Storm Victims Shows Ninety-Nine Per Cent Were Given Shelter By Relatives or Friends."[16] The civic authorities, in the form of the Relief Executive and its two regional committees, did arrange for emergency help for those who needed it. However, people made very few requests for this assistance, so much so that the mayor appealed to those in need in the newspapers, promising that "everything is absolutely private and confidential. ... The clothing, food, or anything else you need is yours by right."[17] The civic authorities also worked hard to restore services needed by everyone in Regina, such as protection from looting, electric power, telegraph and telephone service, and street railway service. ❖

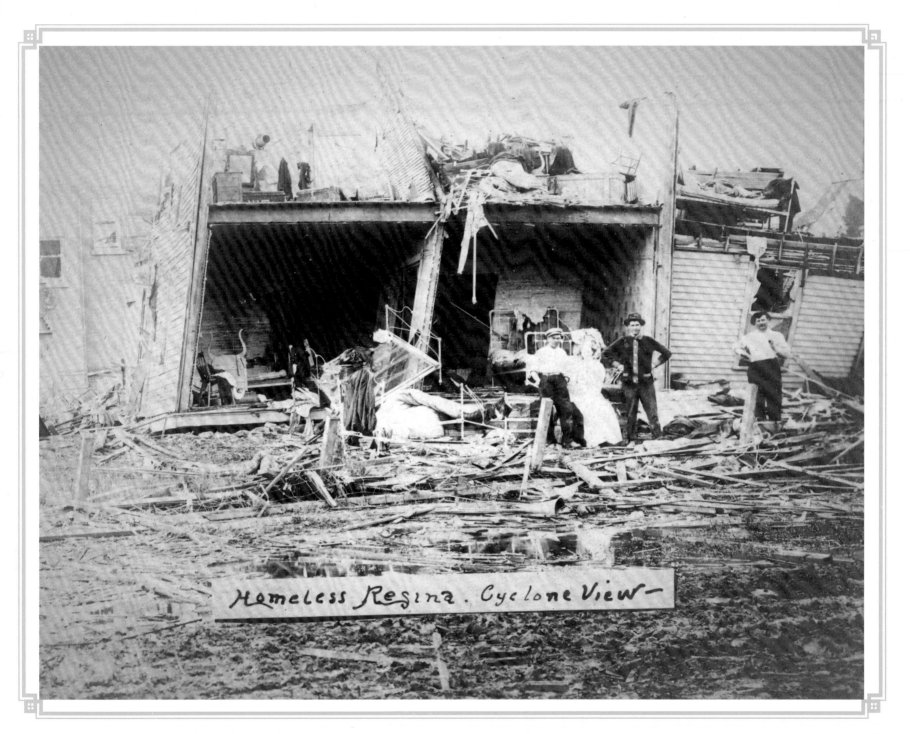

Homeless Regina. Cyclone View—

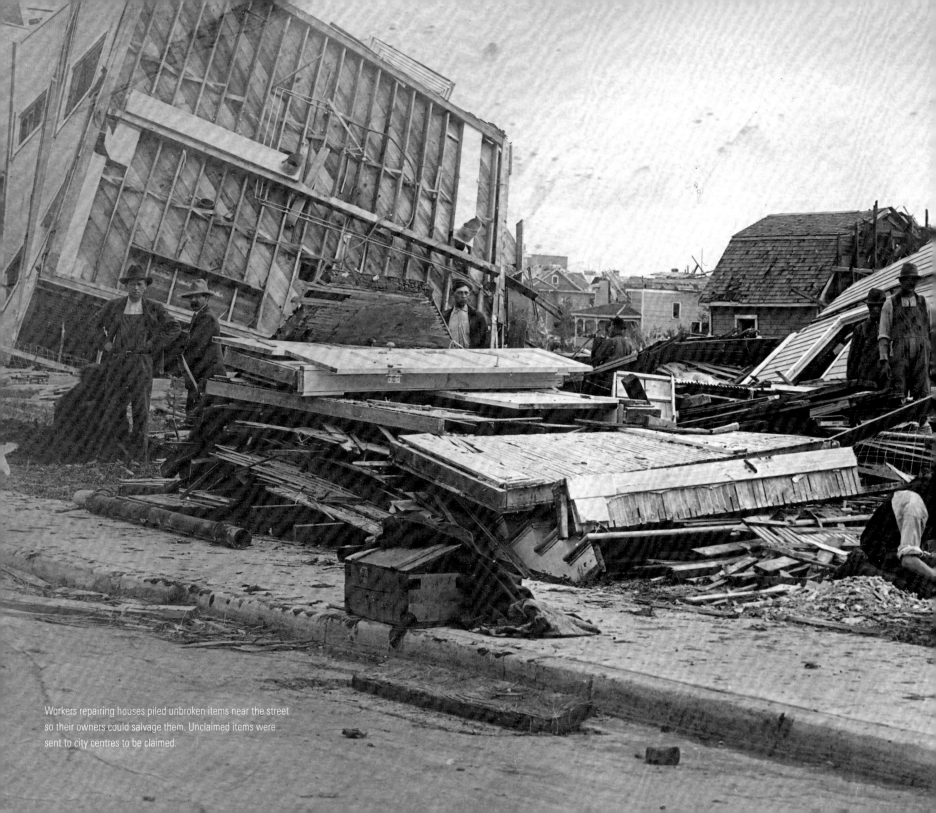

Workers repairing houses piled unbroken items near the street so their owners could salvage them. Unclaimed items were sent to city centres to be claimed.

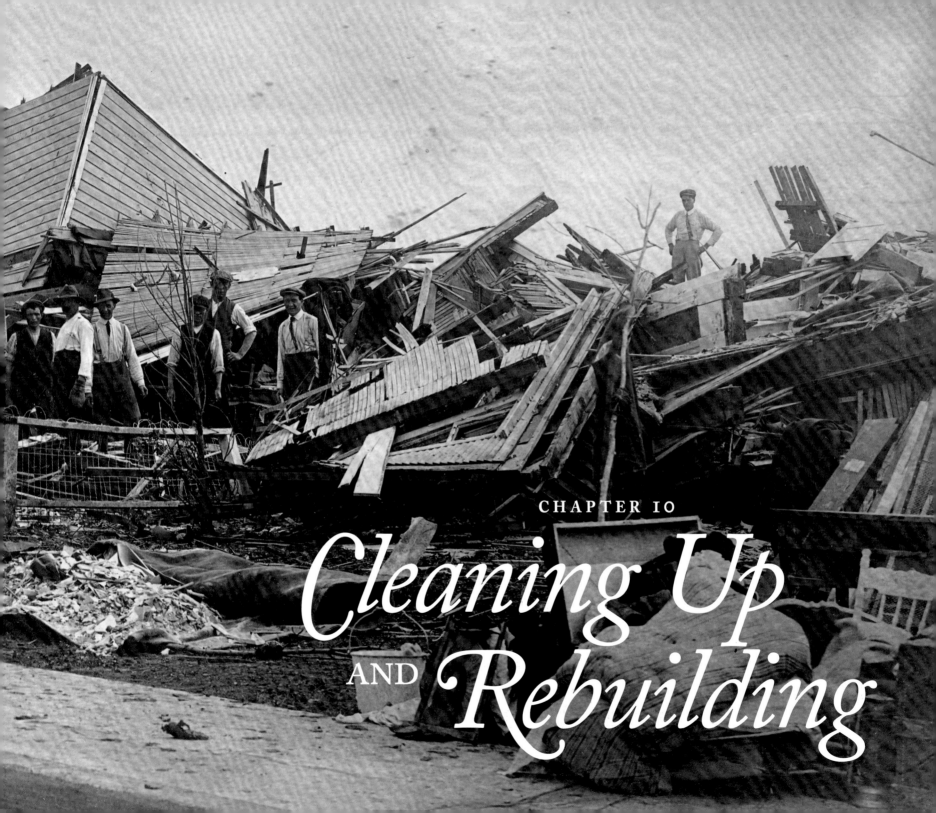

Cleaning Up AND Rebuilding

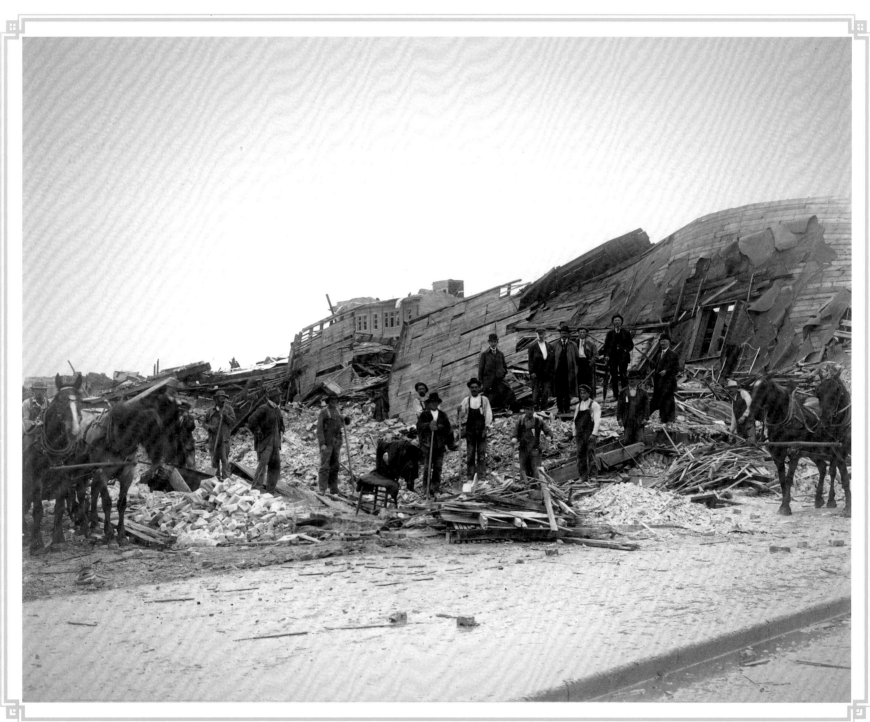

Every photograph of the tornado's aftermath shows rubble piled everywhere, covering lawns, parks, sidewalks, and streets, as well as business premises. Thus, Reginans were faced with the enormous task of cleaning up the mess and replacing the shattered buildings. These tasks fell to three different groups: civic officials, business owners, and homeowners.

One noteworthy element of this task was the positive attitude shown by public officials and the city's newspapers. Even as the papers published photographs showing dozens of wrecked buildings and damage estimates in the millions, they also included headlines such as "Stricken City Rebuilds Bigger and Better Than Ever"[1] and "Work of Rebuilding a Greater Regina Well Under Way."[2]

City officials quickly assembled a large labour force to begin a cleanup of streets, as the *Province* reported at length as early as July 2:

Yesterday saw a very earnest onslaught on to the tremendous task of cleaning up the city and under the vigorous work of large gangs of men enormous piles of wreckage strewn ruthlessly over the pavements and sidewalks of Regina streets melted away like snow on a warm June day.

Under the supervision of the city engineer's department about eighty teams and three hundred men, shortly after seven o'clock yesterday morning commenced the herculean task of straightening out and clearing away the tangled and twisted masses of debris, consisting of lumber, wire, bricks,

stone, cement blocks, shreds of ruined furniture, torn and twisted machinery, dead horses, cattle and dogs and samples of every description of fragmentary crockery and chinaware and other household articles which had been blown in many cases clean through the walls of the ruined houses. A more motley collection of jumbled ruin it would be impossible to conceive. …

All the debris on the north side was hauled away to the nuisance ground and that from the streets south of railway are being piled up in a huge mound on Sixteenth [College] avenue, where what is combustible may be burned later and the remainder teamed away after the first rush is over.[3]

In a later article, the *Province* described this pile of debris as "Brobdingnagian," being 50 feet wide, 5–10 feet deep and stretching from Albert Street to Cornwall, a distance of four blocks.[4]

The city officials asked that property owners in the south be on hand as the cleanup occurred so they could help by identifying their furniture and valuables. The *Province* reported that this was necessary because the workers sometimes put valuable items into wagons destined for the dump: the paper cited this happening to a "sealskin jacket valued at $800" and a doctor's set of pathological slides, both of which were rescued by their owners. The officials also arranged for the collection of unclaimed valuable items which would be stored at a lost property office at Victoria School.

Instructions issued to workers showed that the city was trying to save anything of value which might be reused:

All materials found on private property which may be of use for building, such as lumber, sash, door frames, etc., is to be sorted and piled to one side of the lot.

All furniture, bedding, etc., found in the wreckage, which may be put to any future service, is to be sorted and piled at the front of the lot to be collected by the committee in charge of the storing of furniture.

All small articles of value, of whatever nature, are to be handed over to the citizens' committee on valuables, to be deposited by them in the depots established for the purpose.

All splintered wood and materials that have been broken beyond repair are to be carted away and piled in the places arranged for the purpose, unless special requests are received from the residents, in which case some of the material may be left for firewood.[5]

City workers were also used in some cases to help repair private property, as the *Province* reported:

Two hundred and fifty cars of lumber, the largest order ever placed in western Canada, are to be shipped immediately to Regina for use in rebuilding the portion of the city swept away by the terrific tornado last Sunday.

Already large gangs of carpenters, organized by the city, have commenced to repair the ravages of the storm. After a conference with the city commissioners yesterday morning, the trades and labor union placed about 100 carpenters at the city's disposal. Each street in the area of the storm's pathway, was placed in the hands of a foreman, who immediately made it his business to ascertain which houses in his district could be rendered habitable in a short space of time by means of repairs.

Two supply depots were formed at the Victoria avenue school on the south side and another on the north side of the city. Thither, early in the morning, were rushed large supplies of lumber, nails, laths, plaster and other building materials, and shortly after 9 o'clock the desolated streets rang with the sound of the hammers and saws of fourteen or fifteen gangs of men. They set their backs into the work and by nightfall a number of houses, previously untenable, were ready for occupancy.[6]

The city also made plans to build a warehouse on Halifax Street and 7th Avenue, which would be available for rent to businesses which had lost their buildings to the tornado and whose goods currently "lie exposed to the mercy of the elements" or were stored in box cars which were expensive and not likely to be available indefinitely. This was to be a large, two-storey corrugated iron structure which officials hoped they would be able to rent out even after damaged buildings were repaired or replaced.[7]

One very busy city employee was Building Inspector Omer Falls, whose job was to assess whether or not damaged buildings were safe enough to be repaired or would have to be demolished. He had to deal with both the large public and business buildings and with houses. Property owners were understandably anxious to have his opinion, so he was under considerable pressure. He also had to deal with requests for the erection of temporary structures, some of which he felt were unnecessary because there was space available in undamaged buildings. By July 4, he was able to report that many buildings, both public and private, could be repaired.[8]

Businesses in Regina were as prompt as city officials to take steps to ensure the continuation

of their activities. The *Standard* reported that 64 businesses were affected by the storm to a greater or lesser extent.[9] All of them had to take action to repair or replace their buildings and lost merchandise.

The CPR was the hardest hit enterprise, with most of its warehouses and box cars damaged by the storm. The railway brought in a crew of approximately 500 men and much heavy equipment to carry out the cleanup. One obstacle was a grain-filled elevator which blocked the tracks; the men used a heavy cable to hitch sections of it to a locomotive which, according to the *Leader*, "puffed and snorted and pulled, but over and over again there was scarcely sufficient pulled away for the big gang of men to pick."[10]

Once wooden debris was removed, it was burned rather than hauled away. The company also used a large railway steam crane to lift box cars "from their recumbent position where they were blown by the wind, back on to the tracks where they belong,"[11] but found that some cars were blown so far from the tracks that the crane could not be used on them. The damaged cars were then assembled into what was called a "cripple train" and hauled to Winnipeg for further repair.[12] This work, as well as the rebuilding of the railway's freight sheds, was accomplished in only four days, thus seeming to prove the *Leader*'s prediction that "The new Regina will rise Phoenix-like from its ruins."[13]

Most businesses did not have the manpower or equipment to move as quickly as the CPR, but they did the best they could to continue in business. As early as July 2, the first day the *Province* published after the tornado, in addition to articles describing the destruction and the human misery caused by the storm, the paper included a column headlined "Wholesalers are Busy Securing New Quarters." The secondary headline outlined the plans of specific businesses:

Massey Harris Arranging Temporary Quarters in Old Building—H. W. Laird Will Rebuild Both Wrecked Houses—John Deere Co. Will Utilize Old Building—Cushing Bros Busy Rebuilding—Firms Will Build Permanent Quarters in North Wholesale District."[14]

Of the nine businesses contacted by the *Province*, only two had no comments on plans to rebuild, one of them being Tudhope Anderson whose manager J. J. Bryan had died in the storm. When the *Leader* conducted a survey of progress three weeks later, it found that four of the big firms were already back in business and the fifth would open on August 5.[15]

One of the most proactive businesses was the Laird Company, as the *Leader* reported:

The tornado, as everyone now knows, occurred at 4:50 p.m. when, among the buildings to go down, was the Laird Warehouse on Dewdney Street. At two o'clock the following morning plans for a new building were nearing completion. At six o'clock an order was given—the first that morning—for lumber and other supplies. Yesterday [July 3] operations were already begun on the new structure, which will be rushed to completion. "That's going some," but it is only characteristic of the general spirit that pervades everyone.[16]

" ... THE DESOLATED STREETS RANG WITH THE SOUND OF THE HAMMERS AND SAWS OF FOURTEEN OR FIFTEEN GANGS OF MEN. THEY SET THEIR BACKS INTO THE WORK AND BY NIGHTFALL A NUMBER OF HOUSES, PREVIOUSLY UNTENABLE, WERE READY FOR OCCUPANCY."

The tenants of this building scrambled to salvage their inventory, which consisted of materials ranging from building supplies to stationery and rubber goods, moving them to temporary warehouses on the south side of the tracks.

Downtown business owners worked as hard as those in the warehouse section to salvage whatever they could from their wrecked premises and find temporary places to conduct business. For example, the *Province* reported on July 4 that a temporary structure on the corner of 11th Avenue and Lorne Street was nearly ready to house the businesses formerly in the Crapper Building, which would serve until the latter was

replaced. One particular problem for businesses in many parts of the downtown was broken windows, as the *Standard* noted on July 5:

Stores in the business streets adjacent to the stricken district present a sorry sight. Nearly all of them lost their plate glass, and there was such a demand upon the glaziers that immediately a glass famine was experienced. The consequence is that plate glass is short and dozens of business houses are obliged to board up their windows. A large quantity of glass was sent through by express from Winnipeg, and today the larger effort is being concentrated on replacing broken panes.[17]

Plans and even actual construction were also underway for the buildings surrounding Victoria Park, as the *Province* reported:

Arrangements were completed today [July 4] to rebuild the Metropolitan church; the Baptist church is now under repair and Knox congregation will rebuild or repair as soon as the report of the building inspector is secured. The Y.M.C.A. and Y.W.C.A. will also be immediately repaired. The new telephone building will be on the corner of Lorne Street and Twelfth avenue on property recently secured by the Government. Within a few months, Victoria Square, the pride of Regina, will be more beautiful than ever.

The YWCA was in fact able to reopen its cafeteria for both breakfast and lunch on July 4.

Individual homeowners were also faced with the task of rebuilding, a problem complicated by shortages of manpower and material. These were already in short supply before the storm, so the damage done just intensified

the shortages. Also, homeowners had to compete with the city and businesses to get what they needed.

In many cases, especially in the area inhabited by tradesmen, people did their own repair work. According to the *Province* on July 6,

Up to a late hour many of the owners of damaged houses on the north side, after being at work all day, were spending the remaining daylight hours after six o'clock with hammer and saw repairing their own homes. Some of them were shingling, others were rehanging doors which had been torn off their hinges and many were putting on new roofs.[18]

People scavenged for what they needed in the wreckage and lived in tents or with neighbours or friends while they carried out these repairs. However, there were many houses in their area which simply had to be pulled down because they were so badly damaged.

This situation, in part, was responsible for city council's decision, on July 4, to award a contract for the building of 18 dwellings, five called "cyclone cottages," five called "cyclone houses," and eight shacks which would be built very quickly. The plan was to rent or sell these at reasonable rates to families who needed them. The shacks were made available very soon, but construction on the cottages and houses proceeded at what one historian called "a glacial pace, in sharp contrast to the rapid progress made in constructing the city's own $30,000 warehouse promised to a clamouring business community as temporary accommodation for wholesalers."[19]

Councillors were also motivated by the fear of labour unrest, worried that tradesmen would take advantage of the labour shortage to strike for higher wages or else leave Regina for cities where cheaper and better housing was available. Two relief subcommittees studied the housing problem and then made the following confidential recommendation to council on July 13:

The committees cannot press home too much the need for many city houses to be sold on easy terms or to be rented. The surface looks smooth but there is ugly trouble beneath. Scores of families are being temporarily housed by others already too crowded, or in tents or useless shacks and roofless buildings. These people are waiting for the city to make good. They cannot wait long. These committees in touch with people worst affected believe one hundred city houses … would do more real good than all the other things combined which the city can devise for relief. If the city has the lots and can get the funds for building, by way of a loan, this is the greatest possible means of relieving the people and keeping them here as citizens of Regina.[20]

However, city council did not act on this recommendation, in spite of threatened labour disruption. Early in July, the city's own carpenters, many just recently hired, quit en masse because the city was paying only 45 cents per hour when individuals and businesses were offering up to 60 cents. Painters struck for three weeks starting the end of July, bricklayers walked off for several weeks starting in September, and the carpenters were also threatening to walk off. This led the city to contract for 15 more "cyclone houses," but only 12 of these were actually built. In fact, the civic housing program

Organizations such as First Baptist Church rushed to repair their property to protect it from further damage and to wipe out all signs of the tornado.

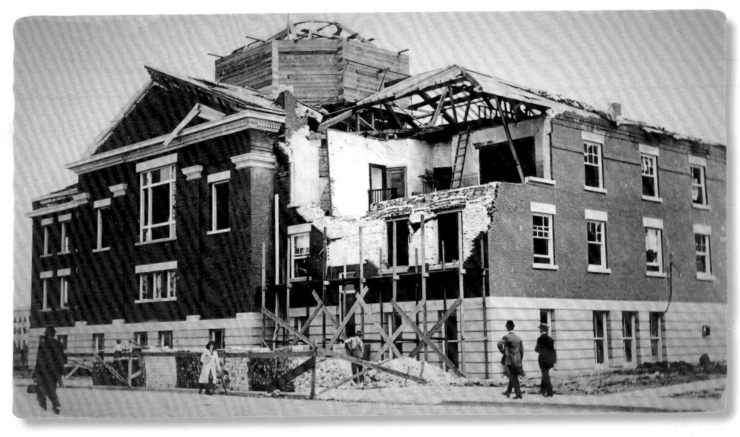

was not particularly successful because by mid-November only three cottages and five houses were being used by either tornado victims or widows without any means of subsistence, and the rest of the houses were up for sale.[21]

People rebuilding their homes needed supplies as well as workers, something Regina's merchants rushed to supply. This demand created the potential for rising prices, something the newspapers cautioned against with an appeal to civic spirit:

Any attempt to exercise extortion or to take UNDUE advantage, for purposes of personal gain, must be frowned down, checkmated and exposed. Let prices remain as they were. Whether we be land lords, vendors, caterers, carpenters, or common labourers, let us not lose sight of the Golden Rule. Thus shall we speedily recover, and in the end the better for a calamity which has already, in a large measure, checkmated selfishness and strife, giving free flow to the soothing sap of human kindness.[22]

In the days and weeks that followed the storm, the newspapers did carry many advertisements about newly arrived building materials, but there were almost no complaints printed about high prices.

There were almost no comments in the newspapers about the process of rebuilding the large homes south of Victoria Park which had been damaged by the tornado. Presumably the property owners hired contractors to repair the substantial damage. The city officials encouraged, or indeed coerced, them to do this by announcing in early August that they would send in city crews, at the owner's expense, to demolish all wrecked or damaged buildings which were not under repair.[23]

The speed at which the physical damage of the tornado was removed and repaired seems amazing. Within a week, most businesses were again functioning, usually in temporary quarters, as were the damaged churches. Individuals and families found places to live, usually on their own although civic authorities provided some help when necessary. The reconstruction activities seemed to live up to the newspapers' optimistic predictions that "Calamity Will Spur Regina People On To New Accomplishments."[24] ❧

Rebuilding homes after the tornado kept carpenters busy for months.

CHAPTER II

Paying THE Bills

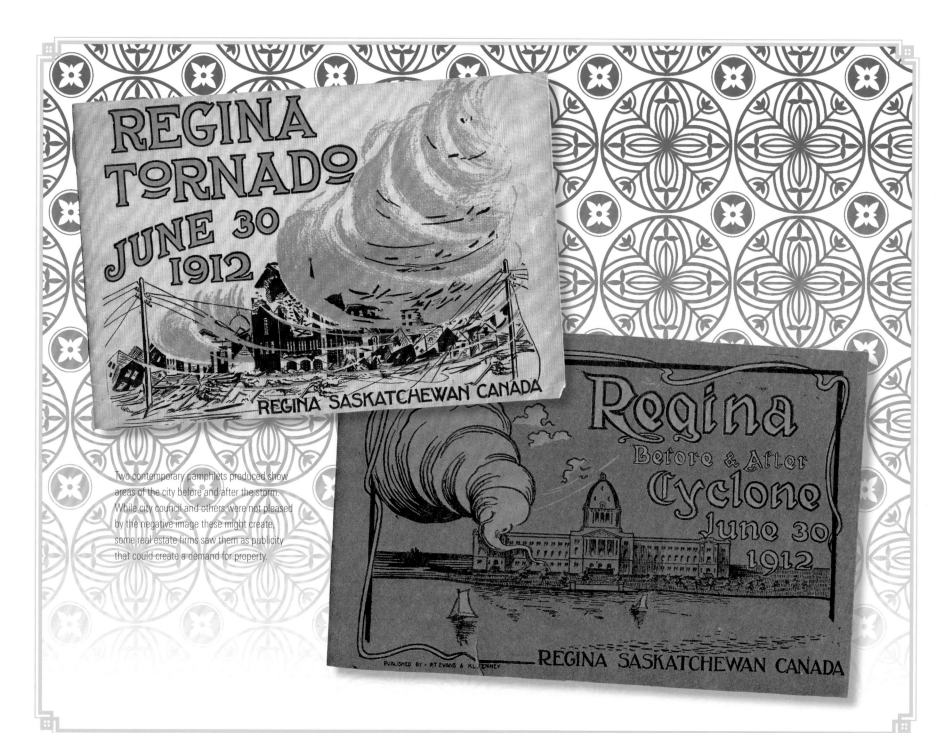

Two contemporary pamphlets produced show areas of the city before and after the storm. While city council and others were not pleased by the negative image these might create, some real estate firms saw them as publicity that could create a demand for property.

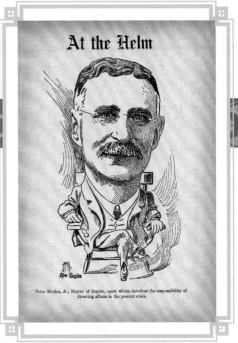

At the Helm

Peter McAra, Jr., Mayor of Regina, upon whom devolves the responsibility of directing affairs in the present crisis.

ABOVE: Mayor Peter McAra, as this sketch from the *Leader* proclaimed, was "At the Helm" of the city and thus had to deal with both the immediate crisis and its financial aftermath.

T he estimates of the damages caused by the June 30, 1912, tornado in Regina have varied widely, both in the aftermath of the storm and in historical reports about it. On the day after the storm, the *Leader* announced, "Five million dollars will be total loss to property holders in Regina, for hardly a building in the city was insured against cyclones."[1] Later newspaper reports gave figures as high at $6 million, but more recently those have been revised downwards to $4 million and finally to just over $1 million. Whatever the exact figure, one question figured prominently on people's minds: where was the money to repair the damage to come from?

Regina city officials had no experience handling disaster relief and no funds budgeted for this activity. The city did immediately send its employees out to help in rescue and cleanup operations, but it was much more reluctant to commit money to provide relief for those who had lost their homes and possessions. Instead, Mayor Peter McAra issued the following proclamation, published in the newspapers:

61,

Canadian Pacific Railway Company's Telegraph

T. D. FORM 2 B.

READ THE NOTICE AND AGREEMENT ON THE BACK

B. S. JENKINS, Gen. Supt., Winnipeg, Man.
J. FLETCHER, Supt., Vancouver, B.C.
J. McMILLAN, Supt., Calgary, Alta.
R. N. YOUNG, Supt., Moose Jaw, Sask.
J. TAIT, Supt., Winnipeg, Man.

W. J. CAMP, Elect. Engr., Montreal, Que.
F. T. JENNINGS, Supt., North Bay, Ont.
W. MARSHALL, Supt., Toronto, Ont.
JNO. F. RICHARDSON, Supt., Montreal, Que.
F. J. MAHON, Supt., St. John, N.B.

JAS. KENT,
Manager Telegraphs, Montreal.

SENT No.	SENT BY	REC'D BY	TIME SENT	TIME FILED	CHECK

Send the following Message, subject to the terms printed on the back hereof, which are hereby agreed to:

Regina, Sask. July 3rd '12.

K.H.Frink Esq.,

Mayor, St. John, New Brunswick.

Your message received. Sympathy deeply appreciated. Extent of disaster- Dead 30 to 50, injured about 150; property loss in neighborhood of $4000000. It is becoming fully apparent that financial aid will be *most* *acceptable* in the near future and any assistance along this line will be gratefully accepted.

urgently required

P.McAra (Mayor)

After investigation of the loss occasioned by yesterday's storm, it is quite apparent that a large measure of financial relief will have to be given to some of those who suffered.

The only way this relief can be given is by the citizens of Regina and others, and in order to carry the scheme out the City Treasurer has been authorized by the Finance Committee of the City Council, and will be glad to receive contributions to *this fund, which will, of course be distributed by the finance Committee in the regular way and audited.[2]*

These contributions, collected in the Regina Cyclone Relief Fund, were to be used to finance non-reconstruction relief, and were administered by various subcommittees, usually staffed by volunteer businessmen.

PAGES 100–104: The City of Regina Archives has hundreds of letters and telegrams written to and from the mayor's office during the weeks following the tornado. Very many pieces of incoming correspondence contained notification of contributions, big and small, to be made toward the relief effort. These came from far and wide; a few examples are provided here.

Contributions quickly poured into this fund from many different sources. Three of the earliest contributions were $25,000 from the Government of Saskatchewan, $5,000 from the CPR, and $1,000 from Regina's mayor as a personal donation.[3] Other prominent Regina citizens followed McAra's example, with six lawyers, 11 businessmen, and 18 who listed their occupations as real estate, finance, or insurance each contributing $100 or more.[4] The Albini-Avolos theatre company, which was in Regina at the time of the storm, staged several benefit concerts, including one on July 1 which, according to the *Leader*, reportedly netted $150 for storm victims.[5] Individuals in other centres also sent funds, including a donation of $5.75 noted as coming from "Toronto ladies."[6] Companies doing business in Regina, such as the Bank of Commerce and the Canadian Northern Railway, sent cheques, as did businesses or organized groups of businessmen who may have benefited from the disaster; two of these included Hiram Walker Distilleries and the Licensed Hotel Keepers Association, whom historian Patrick Brennan noted were probably recognizing "the powerful thirsts generated by the hard work of clearing debris."[7] Contributions both large and small came from outside the city; the citizens of Rouleau, just southwest of Regina, sent $541, while the City

of Winnipeg donated $5,000, and the federal government contributed $30,000. In total, by the end of the summer, the Relief Fund had received $217,949.[8]

The money from this fund was used to help tornado victims meet their immediate needs and replace destroyed household items. Some went to pay medical and funeral expenses, more for food and clothing, and the most, nearly $71,000, to replace furniture.[9] The city established committees to deal with each kind of expenditure, and each set up very strict rules. To have furniture replaced, for example, a claimant had to submit a claim listing his or her needs. The committee then approved the request if they thought the claimant truly needed financial assistance and issued a purchase order showing both the items to be purchased and the price allowed. The claimant then found a merchant who could provide these goods, and the list of the purchases went back to the committee for final approval. Only after this was issued could the claimant get his furniture and the merchant receive payment for it. The committee was pleased with its own operations and reported to city council that applicants exercised "scrupulous care to keep well within the facts" in asking for only what they really needed.[10]

This donated relief was sufficient to deal with small requests but not adequate to cover reconstruction costs for damaged and destroyed buildings. The city government had neither the means nor the desire to meet this demand, so it turned to both the provincial and federal governments for help. As often happened in Saskatchewan, this request for assistance turned into a partisan political issue.

6[1]

No. 1 Bond Street,
SYDNEY- Australia, July 13th, 1912.

The Mayor of Regina,

CANADA,

CITY CLERK'S OFFICE
RECEIVED
AUG 14 1912

Dear Sir:

Cables published in Australian papers describe the terrible disaster that struck your City and prompted me to cable you $100 for relief. The money was sent by my Bank, The Bank of Australasia, Sydney, through their Canadian correspondents, Canadian Bank of Commerce, who would doubtless forward it to you.

Although I am a stranger to you, I may have many friends of my youth in Regina, as I used to live in Guelph 30 years ago.

I feel quite satisfied that the same energy and enterprise which created a City in the past is not lacking now, and that Regina will again take her place as one of the best towns in the North-west.

With sincere sympathy, I am

Yours faithfully,

Frank Coffee

The tornado occurred just 12 days before a provincial election in Saskatchewan, which pitted the ruling Liberal government of Walter Scott against the Conservatives led by Frederick Haultain. In Ottawa, in contrast, the Conservatives of Sir Robert Borden were in power. Thus, each party used the promise of what it called "cyclone" relief to try to lure voters to their side in the upcoming provincial election.

On July 3, the federal Conservative minister of the Interior, Robert Rogers, telegraphed McAra, stating that Ottawa would "be prepared in any reasonable way at all to render such cash assistance as the … circumstances would justify."[11] He also sent Bruce Walker, a trusted agent who was immigration commissioner in Winnipeg, to Regina to report on the situation on July 8, the same day a second telegram promised a loan or loan guarantee based on Walker's report of damages. Walker attended a meeting of city council, giving hints that he realized the need for immediate and substantial funding.

On the same day as Walker's arrival, the Scott government announced a plan to lend Regina $500,000 for reconstructive loans. This provoked a press war in the partisan Regina papers, with the Liberal *Leader* praising Scott's act of statesmanship and the Conservative *Province* calling the promised loan a trick. The issue became part of the newspapers' coverage of the end of the election campaign, which ended on July 11 with the return of the provincial Liberals to power.

With the provincial election decided in favour of its political opponents, the Borden federal government showed no more interest in providing "cyclone" relief to Regina. Walker wrote to McAra on July 19 that there were "obstacles which are practically insurmountable."[12] In early August, McAra and two leading citizens headed to Ottawa to meet with various cabinet ministers, without getting any federal commitment.

Saskatchewan's provincial treasurer, James Calder, also tried to approach Ottawa for a loan on Regina's behalf, but had no more success than the civic authorities. In two telegrams in mid-August, Minister of the Interior Rogers told Calder that financial relief was a provincial matter and that he would not have promised any aid had he known that Scott had pledged money. He ended by stating curtly: "I presume that Regina does not require duplicate loans."[13] Calder tried one last tactic to embarrass the federal government into a contribution by releasing the details of this exchange to the public, information which the *Leader* presented in an editorial entitled "How Bob Rogers Deceived Regina."[14] With all hope of federal funding then gone, the city negotiated terms with the provincial government for a loan of $500,000. The province found money for this by borrowing from the Bank of Commerce.

All during this political wrangling, Regina residents in need of loans to repair their homes had been left waiting for funds. With the issue finally decided in mid-August, city council established a committee to deal with loan applications. Terms of the loans were to be 6 percent interest with repayment in 10 annual installments; the city would hold a second mortgage on the property to ensure repayment. By the end of September, the committee had approved over 80 loans with an average value of $2,500, but enough applications continued to be received that the funds available proved insufficient, leaving some home and business owners scrambling for money. Most of these loan applicants were lower-income individuals who could not get credit from banks, something Regina's more affluent tornado victims had done when relief funds were so slow in coming.[15]

Just like Regina's citizens, its organizations were also faced with the task of raising funds to repair the damages to their premises. A history of Metropolitan Church outlines the problems faced by that organization:

> "AFTER INVESTIGATION OF THE LOSS OCCASIONED BY YESTERDAY'S STORM, IT IS QUITE APPARENT THAT A LARGE MEASURE OF FINANCIAL RELIEF WILL HAVE TO BE GIVEN TO SOME OF THOSE WHO SUFFERED."

Canadian Pacific Railway Company's Telegraph

TERMS AND CONDITIONS

All messages are received by this Company for transmission, subject to the terms and conditions printed on their Blank Form No. 2, which terms and conditions have been agreed to by the sender of the following message. This is an unrepeated message, and is delivered by request of the sender under these conditions.

B. S. JENKINS, Gen. Supt., Winnipeg, Man.
J. FLETCHER, Supt., Vancouver, B.C.
J. McMILLAN, Supt., Calgary, Alta.
R. N. YOUNG, Supt., Moose Jaw, Sask.
J. TAIT, Supt., Winnipeg, Man.

W. J. CAMP, Elect. Engr., Montreal, Que.
W. T. JENNINGS, Supt., North Bay, Ont.
W. MARSHALL, Supt., Toronto, Ont.
JNO. F. RICHARDSON, Supt., Montreal, Que.
F. J. MAHON, Supt., St. John, N.B.

JAS. KENT,
Manager Telegraphs, Montreal.

256. Wn. Cy. X. 69-Paid-3-Exa-(Count-Pns-1-Words-)

Quebec Que. July 6th-1912-

The Mayor of Regina,

Regina Sask-

The Mayor of Quebec offers to your worship the expression of deep sympathy of the citizens of Quebec and acting upon the suggestion of his Lordship Mgr. Mathieu the Quebec City council last night voted you unanimously a contribution of five hundred dollars ($500.o......... has been handed to Mgr. Mathieu for the relief of the sufferers th.......... na... disaster.

Nap Drouin,

Mayor of Quebec.

164bk-

Canadian Pacific Railway Company's Telegraph

TERMS AND CONDITIONS

All messages are received by this Company for transmission, subject to the terms and conditions p... on their Blank Form No. 2, which terms and conditions have been agreed to by the sender of the follow... message. This is an unrepeated message, and is delivered by request of the sender under these conditions.

B. S. JENKINS, Gen. Supt., Winnipeg, Man.
J. FLETCHER, Supt., Vancouver, B.C.
J. McMILLAN, Supt., Calgary, Alta.
R. N. YOUNG, Supt., Moose Jaw, Sask.
J. TAIT, Supt., Winnipeg, Man.

W. J. CAMP, Elect. Engr., Montreal, Que.
W. T. JENNINGS, Supt., North Bay, Ont.
W. MARSHALL, Supt., Toronto, Ont.
JNO. F. RICHARDSON, Supt., Montreal, Que.
F. J. MAHON, Supt., St. John, N.B.

JAS. KENT,
Manager Telegraphs, Montreal

WB X AY 13 1 EXTRA

Lanigan Sask July 7, 1912

Mayor McAra

Regina Sask.

Lanigan people extend sympathy please accept two hundred dollars for relief fund

T J Ecampbell

Mayor

1540

Town of Qu'Appelle

OFFICE OF SECRETARY TREASURER

J. C. STARR, Sec. Treas.

Qu'APPELLE, SASK.

July 6th 1912

The City Treasurer.

Regina, Sask.

Dear Sir;-

I am directed by my Council to forward to you a cheque for $200.00 for the Relief Fund of your City, which please find herewith enclosed.

I am also directed to express the deep sympathy which our Council and Citizens feel with regard to the tremendous loss your Citizens have sustained, not only in property but in the great loss of life by the awful wind storm which you have just experienced.

We trust that by the united efforts of all your City will again recover herself from this dreadful calamity.

Yours truly,

Secretary Treasurer.

There was a first mortgage to the Guelph and Ontario Loan Company at the time for $25,000. This was one of the things not blown away by the cyclone. Many of our members lived in the path of the storm. Their severe personal losses made it difficult if not impossible to give assistance. The building of Regina College [a Methodist high and post-secondary school] and the Church Extension Movement in 1911 also taxed the giving powers of the members of Metropolitan. The parsonage was completely destroyed by the storm; this made necessary a new parsonage and new furnishings.

These combined factors increased the problems the Church had to face. Had it not been for the attitude of the City of Regina in granting loans for construction purposes to those who suffered in the storm, it is doubtful if the Church could have rebuilt at that time.

The City loaned the sum of $60,000 with interest at 6%, taking as security a second mortgage on the Church property, including the parsonage. They also took bonds signed by the Trustees.[16]

This report failed to mention that the Church had to continue to pay existing debts, such as $409 for the final payment on its organ which had been destroyed. In spite of these problems, the building was rebuilt on the same foundations and dedicated less than a year later, on June 8, 1913.

Other organizations used different methods to come up with rebuilding funds. The members of the Regina Boat Club, whose clubhouse on the shore of the lake had been destroyed, voted to form a joint stock company which would sell shares at $10 each, with each member being asked to purchase at least one share.[17]

The Regina Public Library, whose original building had been financed in part with a donation from the philanthropic Carnegie Corporation in New York, wrote again to the corporation with a description and photographs of the damage. Within six weeks, the foundation replied with a promise to donate $9,500 for rebuilding.[18]

A few enterprising individuals and businesses saw the tornado as a financial opportunity. Reports differ about whether or not merchants and labourers inflated the prices for their goods and services, but there is certainly no doubt that these were in high demand in the months after the storm. One group which saw business increase was insurance agents. As early as the first newspaper editions were published after the disaster, advertisements for tornado insurance appeared, a practice which quickly spread to other western Canadian cities. The ads were very successful in attracting customers, as the manager of a large Regina insurance agency told a reporter from the *Standard* on July 15 that his firm had written over $1.5 million worth of policies in the two weeks following the tornado.[19]

After noticing that sightseers were flocking to Regina to see the storm damage—visits highlighted in newspaper headlines—Regina's Exhibition Manager H. C. Lawson decided that this kind of tourism should be promoted in conjunction with the annual fair which he managed. The *Province* reported on his proposal:

> *Many people will be attracted to Regina during the exhibition merely because of the opportunity that will be afforded to see the damage wrought … Mr. Lawson is very decidedly of the opinion that this unlooked for benefit of the cyclone … should be given to visitors to see the ruins are not cleared away at the end of the month by the enterprising owners of property in the devastated area.*[20]

However, this scheme was not popular with city council, which was doing everything it could to see that the damage was cleared away as quickly as possible.

The storm did provide unexpected publicity for Regina in other parts of the country as major newspapers reported on the devastation caused by the storm. In some places this was followed up by pamphlets showing pictures of damaged buildings both before and after the storm, one of which was published by the *Leader*. Mayor McAra and others were unhappy about the negative image this might create, but some real estate companies saw it as publicity which could create a demand for property in the city. One measure of the extent of the publicity about the tornado was the large number of messages of condolence, both telegrams and letters, which the city received from institutions and individuals from all parts of Canada and beyond. Two people who sent their sympathies were the mayor of Sydney, Australia, and the British monarch, King George V. All three newspapers printed many of these messages.

The tornado of June 30 certainly caused major financial problems for citizens, businesses, and public institutions in Regina. The immediate needs were met by volunteer contributions to the Relief Fund, which provided the necessities of life to citizens who could not afford to pay for these themselves. After weeks of political wrangling with the federal authorities, the Saskatchewan government provided a substantial loan which the city used to provide reconstruction loans to both individuals and organizations who needed funds. However, repayment of these loans was one of the problems faced by Reginans in the years to come. ❀

"I AM ALSO DIRECTED TO EXPRESS THE DEEP SYMPATHY WHICH OUR COUNCIL AND CITIZENS FEEL WITH REGARD TO THE TREMENDOUS LOSS YOUR CITIZENS HAVE SUSTAINED … WE TRUST THAT BY THE UNITED EFFORTS OF ALL YOUR CITY WILL AGAIN RECOVER HERSELF FROM THIS DREADFUL CALAMITY"

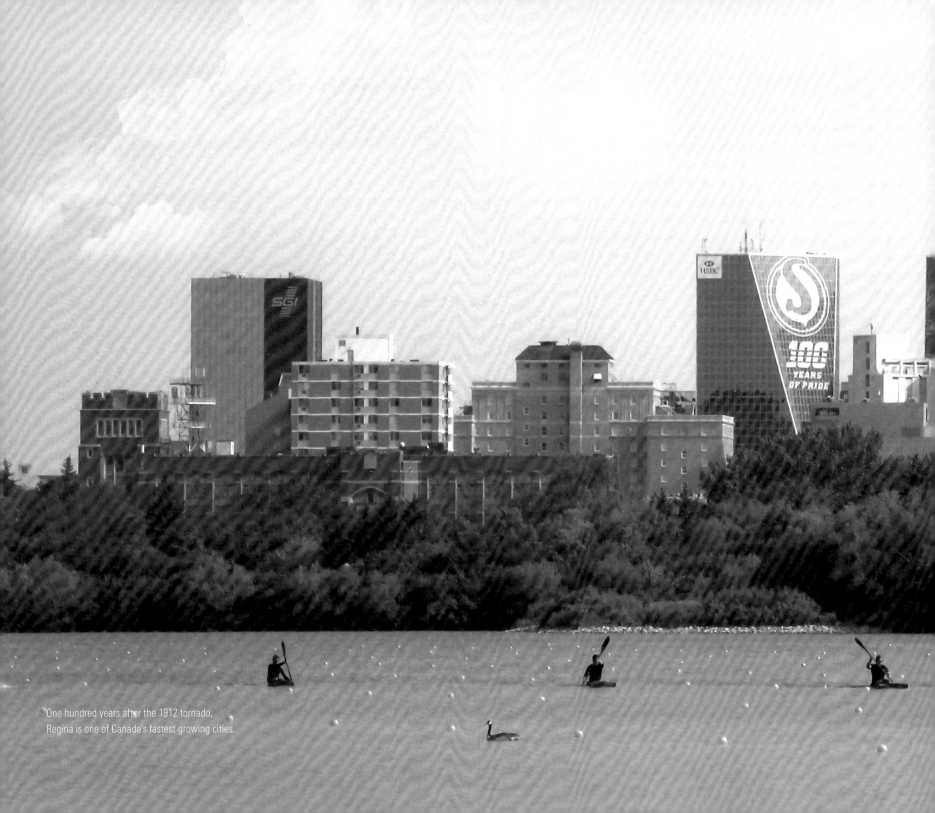

One hundred years after the 1912 tornado,
Regina is one of Canada's fastest growing cities.

THE *Legends*
AND THE *Legacy*

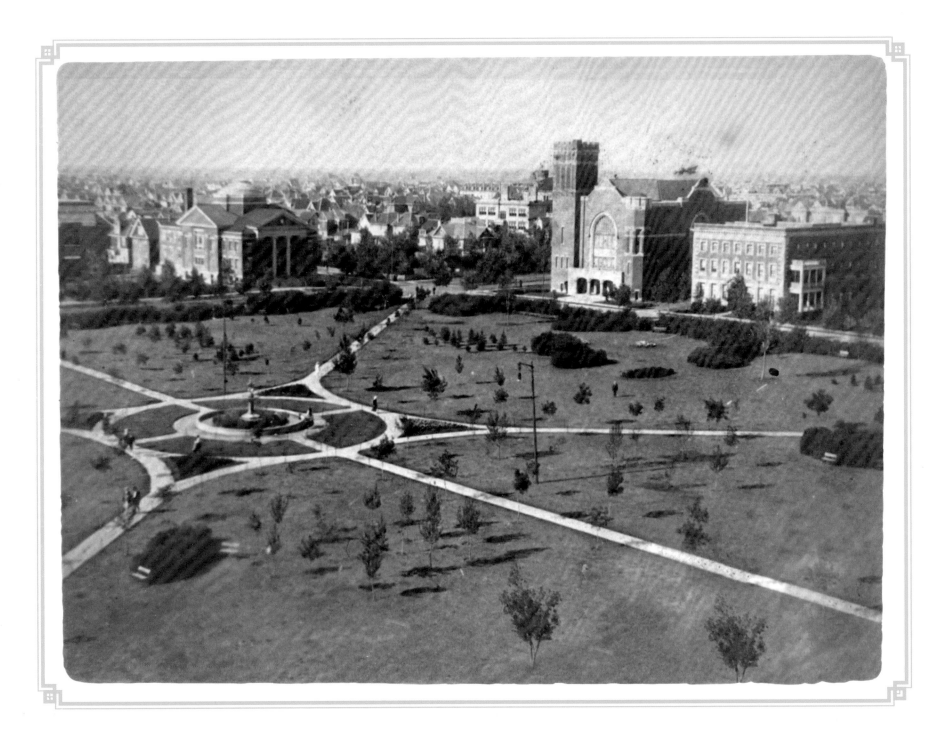

Ever since the so-called cyclone struck Regina on July 30, 1912, people have debated its events and impact. Particularly on anniversaries of the storm, newspapers in Regina and elsewhere publish articles about it. These stories raise issues about the extent of the damage and the experiences of individuals who lived through the terror of the tornado.

One issue raised is the number of people who fell victim to the storm. Early reports of the disaster, often based on comments by bystanders such as George Watt, the grounds-keeper at Government House on Dewdney Avenue west, suggested that 65 people were killed outright in the storm or died in hospital shortly after.[1] All three newspapers gave high early estimates of the death toll which were then revised downward as those reported missing turned up and the rubble of buildings such as Metropolitan Church was cleared without unearthing any bodies. By week's end, the papers were printing lists of the names of 28 fatalities from the city of Regina, and even reporting on the funeral arrangements for these people. They were also including reports on the improving condition of many in hospital who had earlier been reported near death. Modern historians such as Dr. Bill Brennan, University of Regina history professor and author of two histories of the city of Regina, have accepted this lower figure,[2] since the contemporary newspaper reports seem detailed and truthful, and it is hard to imagine

that three different editors would have reason to deliberately reduce the number of dead.

The amount of property damage is another debated issue both at the time of the storm and later. A 1962 *Leader-Post* anniversary article suggested that estimates varied from $4 million to $10 million, figures which seem reasonable based on the devastation shown in the post-storm photographs.[3] This controversy is harder to solve for one reason: almost no one in Regina had tornado insurance so there are no insurance claims on which to base estimates. Individual homeowners, businesses, and public institutions like churches were responsible for their own repairs, and while a few records of reconstruction costs have survived, most have not. In many cases, especially in Regina's north end, homeowners did their own repairs often using material scavenged from the ruins, so costs were minimal. The fact that repairs were made so quickly, particularly by the CPR, makes some of the damage estimates seem high, and in other cases such as the telephone exchange building, the storm simply speeded up construction of a new building which was already in the planning stages. Thus Brennan has used a much lower damage figure of $1.2 million.[4]

The accuracy of individual stories of fantastic survival has also been questioned over the years, particularly in the newspapers. One involves a couple who were walking along South Railway Avenue (now Saskatchewan Drive) after the storm and who found a bathtub from which a naked woman jumped and who ran away down the street,[5] a story which Mayor Peter McAra also mentioned in his memoirs.[6] Since no names were ever given and no newspaper reports covered this event, it cannot be substantiated.

Somewhat similar is a story about 50 horses reported as being "plucked out of their stable by the wind and set down alive in the near-by railway yards."[7] A contemporary pamphlet with photographs of the storm damage includes a picture of the ruins of Mulligan's Livery Stable on South Railway with a caption about 50 horses escaping serious injury, with no mention of them having been relocated.[8]

Two stories often questioned in the newspapers do seem to have evidence to support them. One concerns the background of Frank and Bertha Blenkhorn, the couple killed near the library. Many reports note the irony that they had escaped death only two months earlier when they missed the maiden voyage of the *Titanic*, the ship which sank in the North Atlantic Ocean on April 15, 1912, when it hit an iceberg. The source of this information is the report of their death in the Regina *Standard*, a report which was likely accurate since Frank Blenkhorn had worked at that paper for a few weeks before setting up his own business. Bill Waiser, University of Saskatchewan history professor and author of the most recent history of Saskatchewan, accepted the authenticity of this information in an article he published about these people.[9] The second story challenged is one about the presence of actor Boris Karloff in Regina at the time of the tornado. The city's newspapers make several references to the Albini-Avolos theatre company's activities during the storm period. They were first reported missing and feared drowned on the lake but then found safe and presented several benefit concerts with profits donated to the city's relief fund. Karloff's biographies confirm that he was a member of this company during this time and

took part in these events. Part of the confusion here arises from the fact that Karloff's real name was William Henry Pratt, and that he did not adopt his stage name of Boris Karloff until several years later.

One of the most persistent legends about the tornado concerns boys in canoes flying from Wascana Lake to Victoria Park, several blocks away. These stories are based on various newspaper reports which involved three boys—Leonard Marshall, Bruce Langton, and Philip Steele—all of whom had been at Wascana Lake when the storm struck. Steele's body was found in Wascana Park. The other two survived and talked to reporters, but told inconsistent stories—no doubt because of their physically and psychologically traumatic experiences. There were also newspaper reports of canoes carried by the wind as far as Victoria Park, one with enough force and height that it ended up in a room on the third floor of an office building beside the park. Over time, these reports were scrambled together to create the story about a boy surviving a flight of nearly a kilometre in his fragile canoe, one legend which does not have any basis in fact.

In contrast to the exaggerations and legends about the impact of Regina's tornado, there are many facts on which people can agree. Many of these involve the impact which it had on the individuals who experienced it.

The biggest negative impact, aside from the loss of 28 lives, was financial. Governments, businesses, public institutions, and individuals had to find funds to repair and replace buildings and their furnishings destroyed by the storm. The government of Saskatchewan borrowed $500,000 which it then lent to the City

of Regina to provide loans for citizens and organizations who needed money to rebuild their damaged property. The City was expected to repay both the principal and interest on the loan in 10 annual installments, but soon found itself unable to make these payments because of a recession caused by the tensions in Europe which led to the outbreak of World War I in the summer of 1914. This crisis ended the city's rapid growth and cut its tax revenues. By 1917, the City was so far behind in its payments that the provincial government was threatening to foreclose on land it held as security for repayment. After renegotiations on several occasions, the City was finally able to repay its loan by the end of 1922.[10]

The provincial government also had incurred a debt to find the money to lend to Regina and was much slower retiring this than the city. For 46 years, this loan from the Bank of Commerce was refinanced until it was finally paid off on December 31, 1958, making, as historian Patrick Brennan noted, the bank "the chief beneficiary of Regina's cyclone encounter"[11] because the government's total payments exceeded $1 million.

People who had borrowed money from the city's relief loan fund had the same trouble as the governments in repaying their loans as Regina's economy slowed down in the recession. People who had little or no work could not make their payments, so they feared that they might lose their homes a second time if the city foreclosed on them as it did on several of the "cyclone" houses and cottages. City officials tried to avoid this course of action, wanting to keep people in the city in their own homes, but they were short of funds themselves and needed the money for both their own loan repayments

and maintaining essential services.[12]

Like individuals, organizations also scrambled to pay off their reconstruction debts. For example, Metropolitan Methodist Church had borrowed $60,000 at 6 percent interest, secured by a second mortgage on its property. By 1918, the Church was unable to pay either the principal or accrued interest, so this agreement had to be renegotiated:

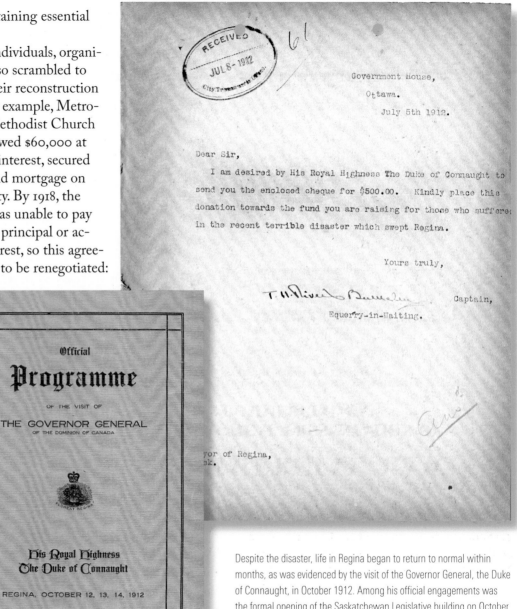

Despite the disaster, life in Regina began to return to normal within months, as was evidenced by the visit of the Governor General, the Duke of Connaught, in October 1912. Among his official engagements was the formal opening of the Saskatchewan Legislative building on October 12, which was described in the official programme pictured here. The Governor General was among the many who sent funds for the city's recovery efforts; this letter sent on his behalf is among the hundreds of tornado-related documents housed in the City of Regina Archives.

An arrangement was entered into with the City wherein they agreed to rebate $10,000 of the debt, reducing the balance to $64,125, on the understanding that monthly payments of $500 were to be made until the debt was repaid. One hundred members pledged themselves to make these payments, as a result of which for the next ten years remittances to the city were made without default and eighteen additional installments were made during that time. The assistance given by the Ladies' Aid and other organizations are worthy of special mention.[13]

Thus, the Church was able to retire its debt because of the personal commitments of its members, but not until 16 years after the storm which caused it. Several other organizations in the city faced similar difficulties.

The financial problems caused by the tornado lasted much longer than the physical ones. By the end of 1912, only a few months after the storm, there were very few signs of damaged buildings anywhere. The CPR had been able to reconstruct its devastated property in only four days, and although other businesses were not so quickly repaired, they were running again, in either rebuilt or temporary quarters, within weeks. On the first anniversary

of the storm, the *Leader* published an edition which contained sixteen pairs of pictures, half showing buildings right after the storm and the other half showing what had since been rebuilt on the same site. Some of these paired pictures showed large homes in south Regina which had either been repaired or replaced with modern apartment blocks. Captions under one pair of pictures described "the half demolished Y.M.C.A." and the same building now "rebuilt with an additional storey and large addition to gymnasium."[14] The ruins of Cushing's planning mill were shown along with a building "rebuilt and today double the size of a year ago," and the picture of the telephone exchange ruins sat opposite of one of the "new telephone exchange now approaching completion. Double the size of the old building."[15] Civic officials also began plans to beautify the city by planting trees,

starting with Victoria Park, which was still to serve as a source of civic pride. In the 21st century, the only remaining sign of the storm is an area of mismatched brickwork on the north wall of Knox Metropolitan Church where construction of the new wall was placed on a portion of the wall of the original structure.

The quick recovery from the tornado occurred in part because citizens from all parts of Regina, damaged and undamaged and rich and poor, worked together to deal with all the problems, especially in the immediate aftermath of the storm. The newspapers were filled with editorials celebrating these volunteers and reminding Reginans of the importance of continued co-operation. Even guests to the city staying in the hotels rushed to ruined buildings to help with rescue work, and men left their offices to work on civic committees or as special constables guarding damaged property. Those with skills in the construction trades were kept busy for the entire summer in rebuilding damaged structures, or as the *Standard* put it on July 4, "every man who can lend a hand is working with a 'hammer in his hand and mouth full of nails'."[16] For at least a brief time, there was more contact between people living in different sections of the city than there had been before the storm, and civic leaders had to consider the substandard housing in which many citizens lived. The storm certainly did not bridge the gap between rich and poor, which was often also between English-speaking native Canadians and immigrants, but it made the former a little more aware of the existence and problems of the latter.

Although "the storm of the century," the deadliest F4 tornado to ever strike Canada,

blew away the homes, businesses, and possessions of about one-tenth of Regina's citizens, including those of many of its wealthy business leaders, it could not blow away their optimistic attitude about the future. The *Leader* presented this sentiment in an editorial only three days after the storm:

Nothing—mark the word, nothing—can check Regina's progress. The Regina of the Future is to be far greater than the Regina of the past.
　There are no men of little faith among Regina's civic leaders. They are men of strong faith and broad vision...
　They know that the Greater Regina is as certain as the rising of the sun.
　And the same feeling of optimism and courage and confidence marks the rank and file as well as the leaders. So it is that the city is rising above its present difficulties and the new and greater Regina has been born out of a disaster which serious though it be, will have but temporary effect.
　The new Regina will rise, Phoenix-like, from its ruins ... for magnificent churches and public buildings, for handsome residences, for substantial business houses, for beautiful streets and noble parks and boulevards will far out-rival the Regina that was so sadly stricken last Sunday.[17]

The commitment made by the citizens of Regina to rebuild their shattered city within months seems to bear out the truth of this statement. ❦

FACING PAGE: Today, the only remaining sign of the 1912 tornado is an area of mismatched brickwork on the north wall of Knox Metropolitan Church. This is where construction of a new wall was placed on a portion of the wall of the original structure.

IN MEMORIAM

George Appleby	Donald Miller Loggie
Bertha Blenkhorn	Laura McDonald
Frank Blenkhorn	Ida McDougall
Andrew Boyd	James McDougall
Ywe Boyuen	Mrs. P. McElmoyle
Joseph J. Bryan	Charles McKay
James Patrick Coffee	Isabelle McKay
George B. Craven	Andrew Roy
Arthur Donaldson	Charlie Sand
Robert Fenwick	James Milton Scott
Etta Guthrie	Mary Shaw
Mrs. R. W. F Harris	Vincent H. Smith
Fred Hindson	Philip Steele
Lawrence Hodsman	Ye Wing

Tornadoes Today

The 1912 Regina tornado was unexpected by the early residents of Regina, who were not familiar with the climate of the Great Plains. But tornadoes are not rare, and continue to be a climate risk. In the spring of 2011, for example, catastrophic tornadoes claimed hundreds of lives in the southern United States in the worst outbreak of extreme weather in decades.

At the University of Regina, researchers are examining extreme climate events like tornadoes, drought and flooding in the Prairies in order to try to prepare for the future. These researchers are working to assist Saskatchewan residents, businesses, government agencies, and communities to adapt to our highly variable climate. While extreme weather events such as the 1912 Regina tornado cannot be prevented, we can prepare for them, and we can do our best to adapt to, and cope with, our challenging and changing Prairies environment. ❀

ENDNOTES

Prologue

1. Frank W. Anderson, *Regina's Terrible Tornado* (Aldergrove, BC: Frontier Publishing Ltd., 1968), 3.

CHAPTER ONE:
The Storm

1. *Leader* (Regina), July 1, 1912.
2. Ibid.
3. *Daily Province* (Regina), July 4, 1912.

CHAPTER TWO:
The City

1. *Regina: The Queen City of the Middle West* (Regina: Regina Board of Trade, 1911).
2. J. William Brennan, *Regina: An Illustrated History* (Toronto: Lorimer, 1989), 190.
3. *1000 Facts About Regina* (Regina: Regina Board of Trade, 1912).
4. Ibid., 2.
5. Ibid., 2–3.
6. Ibid., 27.
7. Brennan, J. W., *Regina*, 58.
8. *1000 Facts*, 14–18.
9. Brennan, J. W., *Regina*, 65.

CHAPTER THREE:
Wascana Park

1. *Leader*, July 1, 1912.
2. John Hawkes, *Saskatchewan and Its People*, Vol. II, (Chicago: S. J. Clarke, 1924), 1136.
3. Montagu Clements, "Storm Clouds Over Regina," *Saskatchewan History* 4 (1953): 21.
4. Anderson, 8.
5. Saskatchewan, *Annual Report of the Department of Public Works 1912*, 85.
6. Peter McAra, *Sixty-two Years on the Saskatchewan Prairie* (Regina: n.p., 1945), 46.
7. Anderson, 9.
8. *Province*, July 3, 1912.
9. Ibid., July 4, 1912.
10. *Leader*, July 1, 1912.
11. Ibid.
12. Ibid.
13. *Province*, July 3, 1912.
14. *Standard* (Regina), July 9, 1912.
15. *Province*, July 4, 1912.
16. *Leader*, July 2, 1912.
17. Ibid.
18. *Leader*, July 3, 1912.
19. Ibid.
20. Ibid.
21. *Leader-Post* (Regina), June 27, 1987.
22. Clements, 22.

CHAPTER FOUR:
"The Best Residential District"

1. *Standard*, July 3, 1912.
2. Ibid.
3. *Province*, July 2, 1912.
4. Ibid.
5. Ibid.
6. *Leader*, July 4, 1912.
7. *Province*, July 2, 1912.
8. *Leader*, July 2, 1912.
9. Ibid.
10. *Standard*, July 2, 1912.
11. Ibid.
12. *Province*, July 2, 1912.
13. *Province*, July 3, 1912.
14. Ibid.
15. *Leader*, July 1, 1912.
16. Anderson, 21.
17. *Standard*, July 4, 1912.
18. *Province*, July 2, 1912.
19. Anderson, 19.
20. *Province*, July 2, 1912.
21. Ibid.
22. *Standard*, July 2, 1912.

CHAPTER FIVE:
In and Around Victoria Park

1. *Leader*, July 3, 1912.
2. Anderson, 23–24.
3. *Province*, July 2, 1912.
4. Lillian Vaux MacKinnon, "My Bed Was Full of Bricks," Regina Public Library (RPL) Clippings file "Regina Tornado 1919."
5. Ibid.
6. *Leader*, July 3, 1912.
7. *Province*, July 2, 1912.
8. Ibid, July 3, 1912.
9. Ibid.
10. *Leader*, July 2, 1912.
11. *Standard*, July 2, 1912.
12. Ibid.
13. *Leader*, July 4, 1912.
14. C. G. Hill to Messrs of the Carnegie Corporation of New York, July 6, 1912, in RPL Clippings file "Regina Tornado."
15. MacKinnon.
16. *Province*, July 8, 1912.
17. Ibid.
18. D. H. Woodhams to Trevor Powell, October 22, 1974, Saskatchewan Archives Board File R-E3520.
19. Dorothy Hayden, *Let The Bells Ring: Knox Metropolitan United Church Regina 1882–1982*, 51.
20. *Leader*, July 2, 1912.
21. Ibid.
22. *Province*, July 2, 1912.
23. Ibid.
24. Anderson, 27
25. *Standard*, July 2, 1912.
26. Anderson, 27; Paul Dederick and Bill Waiser, *Looking Back: True Tales From Saskatchewan's Past* (Calgary: Fifth House, 2003), 22–24.

CHAPTER SIX:
Downtown

1. *Leader*, July 2, 1912.
2. Ibid.
3. Anderson, 32.
4. MacKinnon.
5. *Province*, July 6, 1912.
6. Anderson, 35.
7. Ibid.
8. *Province*, July 2, 1912.
9. *Standard*, July 2, 1912.
10. Anderson, 32.
11. *Province*, July 2, 1912.
12. Ibid.
13. *Regina Before & After Cyclone June 30, 1912*.
14. *Standard*, July 2, 1912.

CHAPTER SEVEN:
The North Side

1. *Leader*, July 1, 1912.
2. Ibid., July 2, 1912.
3. Ibid., July 4, 1912.
4. Ibid.
5. Ibid.
6. Ibid., July 1, 1912.
7. *Standard*, July 2, 1912.
8. *Leader*, July 1, 1912.
9. Ibid.
10. Ibid.
11. Ibid.
12. *Province*, July 4, 1912.
13. *Leader*, July 2, 1912.
14. Ibid.
15. Ibid, July 4, 1912.
16. Ibid., July 2, 1912.

CHAPTER EIGHT:
Caring for the Victims

1. *Regina Before & After the Cyclone*, 1.
2. C. R. Delarue to Elsie, July 1, 1912, quoted in *Leader-Post*, June 20, 1962.
3. Ibid.
4. Hawkes, Vol III, 1807-8.
5. May W. Neal, "Cyclone from a staircase," undated *Leader-Post* clipping, RPL Clipping File: Biography McAra, Peter.
6. Hawkes, Vol III, 1808.
7. Patrick H. Brennan, "It's an Ill Wind That Blows Nobody Good: Regina's 1912 'Cyclone'," in Anthony Rasporich and Max Foran, *Harm's Way: Disasters in Western Canada* (Calgary: University of Calgary Press, 2004), 130.
8. *Standard*, July 2, 1912.
9. *Leader*, July 3, 1912.
10. *Standard*, July 2, 1912.
11. *Province*, July 4, 1912.
12. Ibid.
13. Ibid.
14. *Standard*, July 5, 1912.
15. *Leader*, July 8, 1912.
16. Ibid.
17. *Standard*, July 3, 1912.
18. *Leader*, July 1, 1912.
19. Clements, 4: 19.
20. *Province*, July 2, 1912.
21. McAra, 47.
22. *Province*, July 6, 1912.
23. McAra, 47.

CHAPTER NINE:
Providing Essential Services

1. *Leader*, July 1, 1912.
2. *Province*, July 2, 1912.
3. *Leader*, July 4, 1912.
4. Brennan, P., "It's an Ill Wind," 129.
5. *Standard*, July 5, 1912.
6. Anderson, 47.
7. Ibid., 41.
8. *Leader*, July 4, 1912.
9. Ron Love, *Dreaming Big: A History of SaskTel*, (Regina: SaskTel, 2003), 111.
10. *Province*, July 6, 1912.
11. *Standard*, July 5, 1912.
12. McAra, 46.
13. *Province*, July 4, 1912.
14. Ibid., July 3, 1912.
15. Ibid.
16. Ibid.
17. Ibid., July 4 and 6, 1912.

CHAPTER TEN:
Cleaning Up and Rebuilding

1. *Standard*, July 4, 1912.
2. *Province*, July 4, 1912.
3. Ibid., July 2, 1912.
4. Ibid., July 6, 1912.
5. Ibid.
6. Ibid.
7. Ibid., July 4, 1912.
8. *Standard*, July 4, 1912.
9. Ibid., July 9, 1912.
10. *Leader*, July 2, 1912.
11. Ibid.
12. Ibid., July 4, 1912.
13. Ibid., July 3, 1912.
14. *Province*, July 2, 1912.
15. *Leader*, July 20, 1912.
16. Ibid., July 4, 1912.

17. *Standard*, July 5, 1912.
18. *Province*, July 6, 1912.
19. Brennan, P., "It's an Ill Wind," 133.
20. Report of the House Furnishing Committee, July 13, 1912, Finance Committee of the City of Regina, City of Regina Archives, file 68, 1912, cited in Brennan, P., "It's an Ill Wind," 133.
21. Brennan, P., "It's an Ill Wind," 132–33.
22. *Standard*, July 2, 1912.
23. Ibid., August 1, 1912.
24. Ibid., July 2, 1912.

CHAPTER ELEVEN:
Paying the Bills

1. *Leader*, July 1, 1912.
2. *Province*, July 2, 1912.
3. *Standard*, July 2, 1912.
4. Brennan, P., "It's an Ill Wind," 138.
5. *Leader*, July 2, 1912.
6. *Standard*, July 3, 1912.
7. Brennan, P., "It's an Ill Wind," 153.
8. Ibid., 138.
9. Ibid., 153.
10. Ibid., 139.
11. Rogers to McAra, July 3, 1912, Regina Finance Committee, file 69, 1912, cited in Brennan, P., "It's an Ill Wind," 154.
12. Walker to McAra, July 16, 1912; Brennan, P., "It's an Ill Wind," 140.
13. Rodgers to Calder, August 17, 1912; Brennan, P., "It's an Ill Wind," 141.
14. *Leader*, August 23, 1912.
15. Brennan, P., "It's an Ill Wind," 142.
16. Hayden, 52.
17. *Standard*, July 9, 1912.
18. G. C. Hill to Messrs of the Carnegie Corporation of New York, July 6, 1912, and reply, August 22, 1912, RPL Clippings file Regina Tornado.
19. *Standard*, July 15, 1912.
20. *Province*, July 19, 1912.

CHAPTER TWELVE:
The Legends and the Legacy

1. *Leader-Post*, June 30, 1962.
2. Brennan, J. W., *Regina*, 83.
3. *Leader-Post*, June 30, 1962.
4. Brennan, *Regina*, 83.
5. *Leader-Post*, June 30, 1962.
6. McAra, 47.
7. *Leader-Post*, June 30, 1962.
8. *Regina Before & After Cyclone June 30, 1912*, 26.
9. Bill Waiser, "Stalked by Fate" in Dederick and Waiser, 22–24.
10. Brennan, P., "It's an Ill Wind," 142.
11. Ibid.
12. Ibid., 143.
13. W. E. Mason, cited in Hayden, 52.
14. *Leader*, June 30, 1913.
15. Ibid.
16. *Standard*, July 4, 1912.
17. *Leader*, July 3, 1912.

Bibliographical Essay

There are a limited number of sources of information about the 1912 Regina tornado, but some of them contain extensive information.

Although all histories of the city contain a brief description of the storm, these do not cover it extensively, probably because its impact was fairly limited. There are, however, two longer treatments of the event. One is an article by Patrick Brennan entitled "It's an Ill Wind That Blows Nobody Good" in *Harm's Way: Disasters in Western Canada* edited by Anthony Rasporich and Max Foran and published in 2004. This scholarly article deals with responses to the storm based on newspaper reports and City of Regina records. The second description of the storm is a booklet called *Regina's Terrible Tornado* by Frank Anderson printed in 1968 by Frontier Books. This 50-page volume has several strengths, including two useful maps and 25 photographs. It provides a very readable description of the storm's passage through Regina based mainly on eye-witness reports which appeared in newspapers. However, Anderson's book has two weaknesses. One is a very cursory treatment of the aftermath of the storm, and the second is a complete absence of footnotes and only a brief list of references.

The best primary sources of information about the tornado are the three Regina daily newspapers, the *Leader*, *Province*, and *Standard*, which provided extensive coverage of the storm in the week following it and more limited coverage in later editions, with the storm being driven off the front pages by the provincial election held on July 11, 1912. Reporters interviewed both victims of the storm and the civic officials dealing with it. They also compiled lists of injured people and property damage which covered pages of the papers, and published numerous photographs of the damage. Some of the early reports contain exaggerations of casualties and damages, but these were usually corrected in later editions. Newspapers from other cities covered the event, but their articles did not contain the same level of detail as the local papers.

There are also some firsthand accounts of individual experiences in files in both the Saskatchewan Archives Board and the Regina Public Library, some from personal correspondence and others that found their way into newspapers sometimes years after 1912. One of these by Clement Montagu was published in *Saskatchewan History* in 1953. Histories of organizations such as Knox Metropolitan Church and SaskTel also contain some reminiscences of the storm.

The Saskatchewan Archives Board holds an extensive collection of photographs of both pre- and post-tornado Regina, and the City of Regina Archives also has relevant photographs and documents. Two contemporary pamphlets, *Regina Before & After Cyclone, June 30, 1912* and *Regina Tornado, June 30, 1912* also contain photographs. ❧